PHOTOGRAPHING HISTORIC BUILDINGS

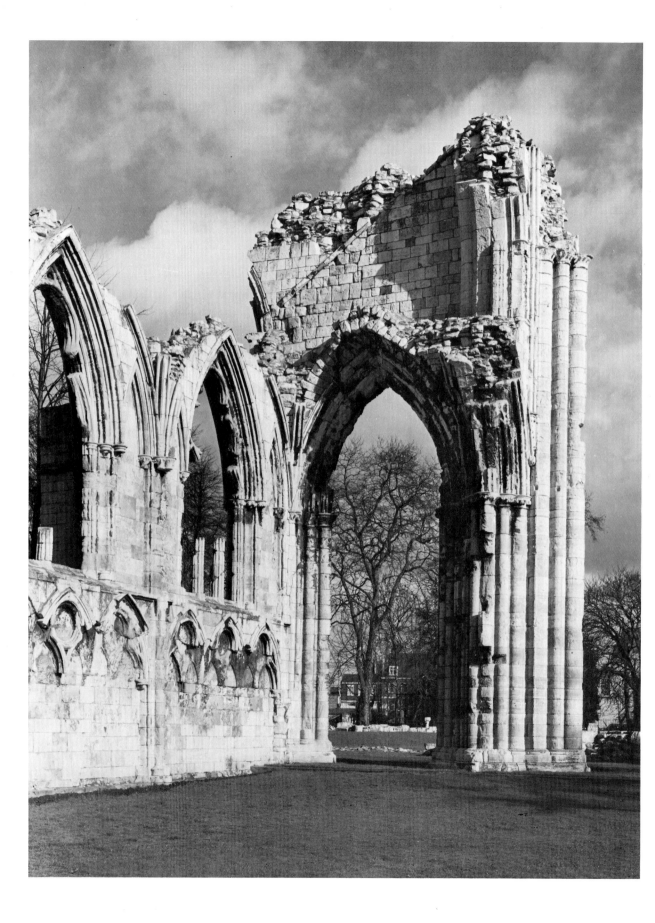

PHOTOGRAPHING HISTORIC BUILDINGS

for the record

TERRY BUCHANAN

LONDON: HER MAJESTY'S STATIONERY OFFICE

© Crown copyright 1983
First published 1983
Second impression 1984

ISBN 0 11 701123 1

HER MAJESTY'S STATIONERY OFFICE

Government Bookshops

49 High Holborn, London WC1V 6HB
13a Castle Street, Edinburgh EH2 3AR
Brazennose Street, Manchester M60 8AS
Southey House, Wine Street, Bristol BS1 2BQ
258 Broad Street, Birmingham B1 2HE
80 Chichester Street, Belfast BT1 4JY

Government publications are also available
through booksellers

Author's Acknowledgements

The author is grateful for considerable assistance from
a number of colleagues, especially Mr. E. Barbour-Mercer,
Mr. R. Parsons and the staff of the Photographic Section,
Mrs. J. Bryant, Miss P. Boniface and the Secretary to the Commission.
The book was designed by Mr. G. Hammond, HMSO.

Front cover: The Thatched Cottage, Thornton Dale, North Yorkshire
Back cover: The City of York from Clifford's Tower

Printed in the UK for Her Majesty's Stationery Office
Dd 736288 C40 12/84

Foreword

This book is by a photographer and is primarily *for* photographers or, may we say, for all those with a good modern camera looking for something worthwhile on which to use it. The selection of photographs on which it is based is entirely from the National Monuments Record, a part of the Royal Commission on Historical Monuments (England). All the photographs are by the Commission's professional staff, many by the author himself. Though all are of buildings, our main purpose here is to demonstrate how such photographic records can be produced rather than to enlarge on the historical interest of the buildings themselves. The need for such records to be made far outstrips the Commission's resources; damage to and demolition of the country's heritage of historically significant buildings continues to be widespread and more records of them are needed now. Many people who enjoy both looking at old buildings and taking photographs may welcome the idea that their two interests can combine in a work of lasting value, that is of contributing to the national archive in daily use by scholars, planners, teachers and conservationists.

Photography as discussed here has a broad historical aim. People are fascinated by what places they know used to look like (as a spate of picture books shows) and by the vivid sense of a past way of life anywhere; the setting of past events and the evocation of people's daily lives are of compelling interest. Hence photographs of interiors with characteristic furnishings and of places decorated for special events are also of interest to us as well as the far commoner straightforward architectural photograph. In illustrating successful methods and acceptable standards, our hope is to encourage others to emulate them. If, in addition, those so encouraged offer their photographs to the National Monuments Record, or other appropriate repository, we shall be doubly pleased.

P. J. Fowler
Secretary,
Royal Commission on Historical Monuments (England),
Fortress House, 23 Savile Row, London W1X 1AB

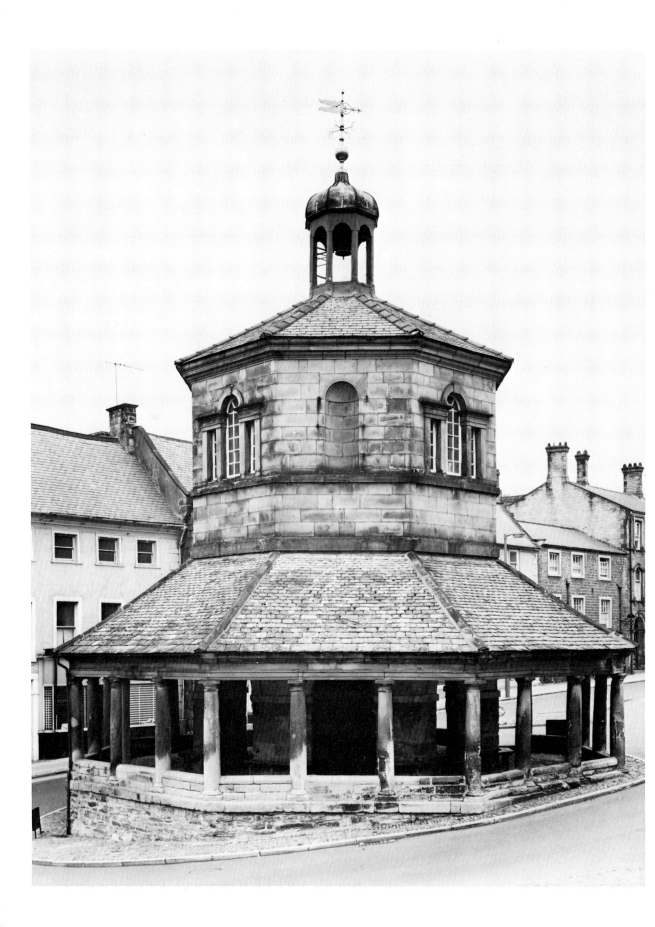

Contents

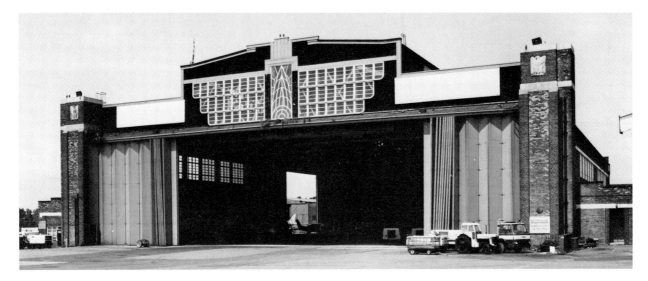

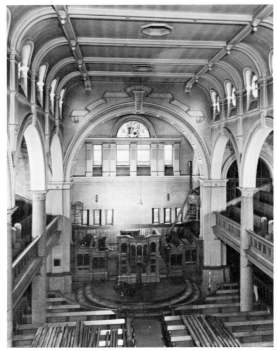

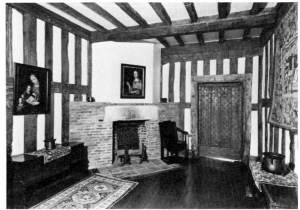

Author's Preface

Any catalogue of types of buildings would be vast in range, from the smallest to the largest, from the oldest to the most recent, from the terrace house to the stately home. Most of us spend some part of our day in a building, in a house, factory, office or church. Many of these buildings prompt more than just a passing interest. The mills, chapels, castles, ware-houses, public houses are part of the history of our way of life; they are historic buildings.

Looking at old and historic buildings, especially stately homes, has become part of the British way of life. Many people are content to do no more than look but others also enjoy photographing the architecture and the following pages have been written for them.

In architectural photography, no substitute exists for practical experience gained in many different situations. A basic guide such as this, based upon professional experience may, however, provide some useful information and guidelines for the amateur photographer. It is intended for those who use small and medium format cameras with interchangeable lenses and a full range of shutter speeds.

Many people buy a 35mm single-lens reflex as their family camera and with it produce good quality results from the very first roll of film. The professional photographer of architecture has a much more demanding task. He prefers a large format camera with movements that allow full control over the image before the exposure is made. Nevertheless, apart from the rudimentary snapshot cameras, the small modern camera, especially the single-lens reflex, is a very versatile and sophisticated instrument. Used with forethought, it can produce informative and lasting records.

Many of our historic buildings are being changed or damaged; some are disappearing. Records of what exists at present will be of immense value to historians and future students of architecture. The value of these records can only be realized if the negatives, together with adequate written information, are deposited where access to the information they contain is freely available to everyone.

The National Monuments Record and local record offices undertaking the task of maintaining a photographic archive take that responsibility very seriously. The preservation of the photographic image is the subject of much discussion and international research to ensure that the photographs we take will survive for the enlightenment of future generations.

Photographing historic buildings can be an absorbing enterprise for the photographer; if pursued seriously, it makes demands and provides satisfactions far beyond the merely technical. It is hoped that this book will set some on the first step along an alluring path: a path which usually leads at first to somebody's front door.

T.B.
July 1983

The Photographic Record

History

While on a visit to Italy in 1833, William Henry Fox Talbot of Lacock Abbey used a camera obscura to form small images over which a line could be drawn to produce a more permanent image. These experiments were the starting point of his development of the negative-positive photographic process which remains unchanged in principle to this day. Before long, photographers began to produce architectural records which later became the basis of some present-day collections.

Although numerous important buildings still need photographic coverage, many of the more common buildings of historical interest must also be recorded if we are to produce a balanced archive of our architecture through the ages. This task is urgent because demolition or alteration will in time leave little in its original or present-day condition.

Buildings that individually go almost unnoticed but collectively dominate our everyday world are urban dwellings of all types, railway stations, factories, mills, farmhouses, cottages and farm buildings. If photographic records of these are produced to a high standard and deposited as negatives or prints in a public collection, the sum total will be an archive of lasting historical value.

This can be done economically if selection is practised according to architectural criteria. That does not necessarily entail a deep knowledge of architectural history, but an ability to recognize the salient features of a building is essential. Such can be acquired by reading, by studying the work of others and by starting to make a photographic record in a systematic manner.

Preliminary precautions

Before embarking on the photographic coverage of a building or buildings, it is always worth checking with national and local repositories that your chosen subject has not already been recorded. If it has, they should quickly be able to advise you of gaps in the archive which you might like to consider if you wish your work to be most useful.

When any building is to be photographed, the first step is to contact the owner or occupier for permission to do so. Explain that the photographs are to become a record for historical purposes. It is usual at this time to offer a complimentary set of prints to an owner who gives the necessary permission.

The next most important consideration is safety. Never smoke in any building; leave matches or lighter at home, for left in a derelict building or elsewhere they would be obvious temptation to any child who might find them. Uninhabited buildings are best visited by two or more people; if this is not

Although a building may have open access, always proceed with caution. Warning notices invariably mean what they say.

Where an interior contains obviously combustible material, as in a carpenter's workshop, or has an explosive atmosphere, as in a grain-filled barn, flashbulbs should be used only with extreme caution. In any potentially hazardous situation, preference must be given to electronic flash. If in doubt always seek advice.

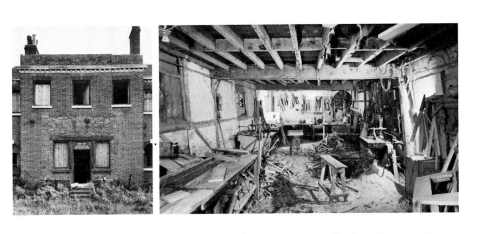

possible, ensure that someone knows where you are and when to expect your return. On setting out, a map of the area (Ordnance Survey 1:50000 First Series) to locate buildings and a compass to relate elevations to the cardinal points will be required. A notebook and pen are necessary to make a written record of photographs taken; so too is a torch, preferably heavy duty, powerful and with spare, fresh batteries. Protective clothing must include heavy-soled shoes under which a rusty nail is likely to bend rather than penetrate; industrial chrome-leather gloves can likewise protect the hands from sharp or rusty objects.

Exteriors

Equipment

Traditionally the large-format camera has been most useful in recording architecture but, for those willing to take time and care, excellent results are also possible with 35mm equipment.

The main disadvantage with the 35mm camera is the lack of a rising front with all lenses. Some lenses, however, are available with a perspective-control movement which enables correction to be made on the negative to avoid the convergence of architectural verticals. The inexperienced in this field may not realize that a wide-angle lens has the capacity to approximate to the simplest movement on a view camera – the rising front – simply by exploiting its wider angle and cropping the unwanted foreground in printing. Even the disadvantage of a fixed lens may be overcome when the building can be photographed from a high viewpoint or minimized when it can be photographed from some distance away.

A medium-speed film of ISO 125/22° will give consistent results of good quality. To allow controlled development over a wide range of subjects it is preferable to use the shorter lengths of twenty exposures that are available in black-and-white film.

A good sturdy tripod, a cable-release to enable long exposure without camera shake, and an efficient lens hood to prevent flare are essential. A polarizing screen or filter reduces strong reflection from glass, smooth glossy non-metallic surfaces and water; and is perhaps the most useful one for architectural subjects. As it is expensive, however, those cameras which have each interchangeable lens fitted with front filter-mounts, all of the same screw-thread diameter, have the

The large-format camera with its full range of movements can be restrictive to the amateur, but is the ideal choice of the professional architectural photographer.

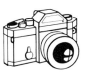

The 35mm single-lens reflex camera is more suitable for the enthusiast, whether his main interest be historic buildings or photography.

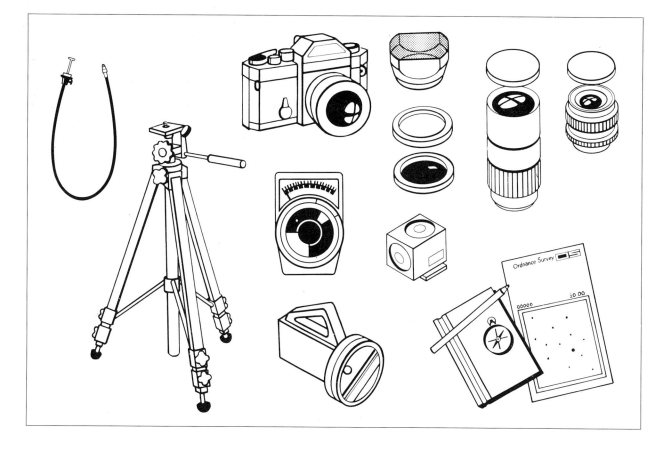

Basic personal needs are: map and compass, torch, notebook, pen or pencil, strong shoes, old gloves, waterproof clothing.

Basic camera equipment is: exposure meter (even if the camera has one built in), tripod, cable release, lens hood, spirit level, polarizing filter, flashgun. To this list can be added: wide-angle lens (28mm), telephoto lens (100mm), coloured filters. These modify the light passing through them:
Yellow — darkens blue sky, lightens yellow stonework.
Green — darkens red brickwork, lightens green foliage.
Orange — darkens blue sky, lightens red brickwork.
Red — darkens blue and green, lightens red brickwork, increases image contrast.

advantage. A coloured filter to accentuate colour contrasts is useful where a building has patterned brickwork or is constructed of different materials. Lenses, although dictated to some extent by the size, location and shape of a building, will be very much a personal choice. To obtain maximum information on the film in restricted situations, perference should initially be given to lenses with a wider angle of coverage rather than to those with a normal focal length.

The last essential piece of equipment is a small spirit level to ensure that the camera is parallel to the planes of the building before making the exposure.

Photographing

Ideally, all the elevations of a building should be photographed. To complete the record on one visit, the best light is that from a bright but cloudy sky. Begin with a preliminary walk around, making notes of viewpoints which will show such evidence as structural phases, stylistic features and building materials in the most informative way.

If the building has to be photographed on a sunny day then the camera should be fitted with a lens hood and, in addition, a shadow should be cast across the lens area with the hand. This is to prevent a flare-diffused image; the precaution is much easier to carry out if the camera is on a tripod. A straight-on photograph of an elevation from a central viewpoint can relate directly to surviving architects' drawings and, providing the camera is level and parallel to the elevations, allows reconstruction drawings to be more easily made.

Date-stones are important and care should be taken to search for them. It is essential to record them both in detail and in the context of their surrounding area. Any such stone might not be an original part of the building or in its original position.

Dates, commonly found on porches, over doorheads, on chimneys and rainwater heads, in plasterwork or anywhere else where they are painted, raised or inscribed, should be meticulously recorded, both in the notebook and by the camera. Having made the record, however, do not jump to the conclusion that you have 'dated' the building: such 'written evidence' often relates to a rebuilding or addition and may well not even be in its original position.

Easily moveable items, including vehicles, that make exteriors look untidy should if possible be removed from camera-view. This is to avoid the possibility of obscuring detail as well as for aesthetic reasons; the full co-operation of the householder is of course essential. If the building is near your home, then choosing the most convenient time when every condition is favourable should be easier, even if this means an early-morning start on a Sunday. External details, for example doorcases and window surrounds, areas of contrasting materials, straight joints in masonry, should all be photographed in the simplest possible way. Artistic camera angles should be avoided if they are likely to reduce and distort the amount of information recorded and thereby waste your efforts on a record of no great value to the architectural or social historian.

Domestic interiors

Equipment

Photographers of architecture have usually concentrated on the pictorial or atmospheric quality of a subject; as a result, dark areas have often been left dark on the final print. The present and more useful trend is to provide maximum information on the negative so that informative detail appears in both the highlights and shadows. Unless the interior is evenly lit the only way to produce

Flashbulbs are an excellent lighting source in architectural photography but their use by enthusiast photographers has greatly diminished.

Electronic flash, portable and with built-in computing sensor, is now the most widely-used form of lighting. A second flashgun with a light-triggered slave unit will increase versatility.

Mains lighting of the photo-flood and quartz tungsten halogen type is obviously restricted to the availability of a power circuit. Its main advantage over flash is that the effect of the lighting can be seen before the exposure is made.

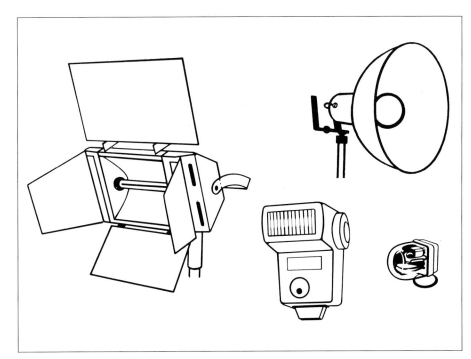

such information is with artificial light. If the building has a working mains-circuit then high-wattage lamps of the photoflood or quartz type can be used. An ideal compact lamp is the one normally used for indoor ciné-photography.

Electronic flash is very compact but, having a small light source, it produces harsh shadow and a limited area of light coverage. Two or more flashguns will allow greater flexibility in lighting and eventually produce more satisfying results. Additional flashguns can be operated without connecting cables by using a slave unit, which enables them to be fired when the shutter contact in the camera operates the main flash.

Tripod, spirit level and torch are again essential. A wide-angle lens to obtain maximum information in general views, and standard focal length for the details, will keep the equipment down to a manageable minimum.

The wide-angle lens is normally chosen as a second lens in the photography of buildings. Providing the camera is levelled accurately, the wide-angle lens enables much more information to be recorded, which is the aim in this kind of photography — collecting visual information.

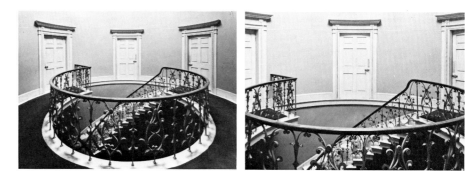

Lighting

(i) Available light

Interiors lit by the available daylight usually have a range of contrast outside the limits that film can normally record. Contrast can be controlled to some degree by over-exposing in the camera and then reducing the development time used to produce the negative. This need to control contrast is the main reason for the advice about using short lengths of film; they make it easier to keep all naturally-lit interiors, for example, on one roll. If both interior and exterior subjects are mixed on the same film, the controlled development for one type of subject can be detrimental to the contrast of the other.

Sometimes the exposure-meter will indicate the need for an exposure-time longer than one second. If so, light must be allowed to enter the camera for an even longer period in order to form its latent image in the light-sensitive film emulsion. This enables enough energy to be generated within the latent silver image to produce reasonable density in the visible image after development. The following table indicates how much increase of exposure above the meter-reading is required for an evenly-lit interior with the windows excluded from the view.

Meter-indicated exposure time	Exposure time required
3 secs	4 secs
6 secs	8 secs
9 secs	12 secs
15 secs	20 secs

Where the interior view includes a window, the exposure reading should be taken

from a darker area of the room and exposure time increased in accordance with the table. The film is then developed for up to one quarter less than the recommended normal development time.

(ii) Flash-light

The camera should be fixed on to a firm tripod to enable the scene to be illuminated by several flashes from an electronic flashgun, which preferably should not be attached to the camera. If the camera does not have a double exposure facility then it can be set on 'Time' or 'T' and the lens covered with a lens cap. Once the shutter is locked open, the exposure can be made by removing the lens cap and firing the flashgun, possibly activating a second flashgun which is connected to a slave unit.

The flashgun should be pointed towards a different area of the scene for each part of the exposure. A computer-type of gun is desirable to produce the correct amount of light for parts of the subject which are at differing distances from the flash source. If the basic non-computer flashgun is used, the flashes should be at the same distance from each separate part of the scene to ensure correct exposure. The distance can be calculated by dividing the number on the lens which indicates the aperture setting (e.g., f/8 use 8) into the flashgun guide number which will be related to the speed rating of the film in use.

(iii) Artificial light

Incongruous as it may be, some rooms in old houses, usually the kitchen, have fluorescent lighting. This provides an ideal source of illumination; even if the tube appears in the photograph, it will not be distractingly bright.

Where illumination has to be provided by a photoflood or quartz lamp, first ensure that the lamp-housing is earthed, that the plug is fitted with the correct fuse and that the circuit is not so old that to overload it would create a danger. It is sometimes possible to plug a photoflood into an existing light socket to increase illumination; but never do so if the ceiling is covered with polystyrene tiles or until the lamp shade has been removed. The lighting should be switched on for just long enough to take the exposure-meter reading and to make the exposure. A better method is to use a photoflood in a brass socket, within a metal reflector, taking power from a ring-main circuit by a sufficiently long cable. Much heat will be generated so the photoflood should be fixed to the top of a firmly-based lighting stand. Maximum light can be directed towards the subject area.

Another method, and one in which the equipment is easier to handle, involves using a high-wattage lamp of the type made for indoor ciné-filming. This has a handle to enable the illumination from the lamp to be moved easily over a large area during the period of exposure. By letting the light rest for a longer period on those areas furthest away from the light source and rest for a shorter period on those nearest the light source, an even exposure can be obtained on the negative. This method is practicable if a small aperture can be used to provide a suitably long exposure time; its advantage is that the moving light tends to soften the edges of any shadows.

Great care should be taken with quartz lamps. Although usually protected by a transparent heat shield and metal adjustable flaps, they generate enough heat, even for a period after being switched off, to cause a serious burn if placed in contact with any surface.

Tungsten lighting, where possible, should be the first choice of the enthusiast photographer of historic buildings. By using a constant light source on a stand, experience of the effect of light upon the subject will be gained. This knowledge can then be put to good use when flash-light sources are being used.

It is the details that tell the story: the phases in the development of a building, the alterations made since it was first constructed. They also show, in a way that no general view can, the materials used, any textural contrast, and indicate limitations imposed by contemporary tools and working methods. The record of significant detail is vital to understanding a building.

Details

In architectural photography, details are often as important as general views. Externally, doorcases and window surrounds, for example, or areas of contrasting materials or constructional breaks in walling or peg-holes in timber-framing can all represent significant detail. Internally the counterparts might be, for example, a staircase, a door surround, a ceiling, a stop on a chamfered beam or the exposed undersides of floor joists.

Sometimes the photographer comes across old photographs or drawings of the building he is in; if the owner is agreeable these should be photographed at the time. Most modern 35mm single-lens reflex cameras are capable of being focused at very close distances so that the size of the original should present no problem. To minimize reflection the general rule in copying, especially if the original is covered by glass, is for the subject to be in a light area and the camera in a dark area. If the original has printed or drawn lines on thin paper with similar lines on the back surface, then contrast will be improved on the record photograph by placing a sheet of black paper behind the original. In the case of a drawing, and especially if it is to be redrawn later from the photograph, the main requirement is for the camera to be central and parallel to the subject.

Processing the record

The negative

The photographer of architecture who uses black-and-white film must try to exercise some control over lighting contrast or extreme brightness range in the subject. The aim is to produce a negative with gradation of density from shadow to highlight that will print, on a normal grade of paper, with minimum effort from the printer. This is easier with black-and-white film, for its simple development process and ability to produce good results over a wide range of exposure allow much variation from the manufacturer's recommended exposure and standard development times. Such variation is essential if contrasts are to be adequately controlled. Interior subjects photographed with dark shadows, bright highlights or shafts of light, create an impression of atmosphere but do not provide an adequate architectural record. The negative should show what is there, good or bad, in all its detail.

Colour

Colour film is now probably more widely used than black-and-white by non-professionals, but its ability to produce a permanent archive is still in doubt. Synthetic dyes used in many modern reversal colour films are prone to the effects of fading, not always evenly, within the separate parts of a three-colour layered emulsion. Colour photography is nevertheless important, especially where colour is an essential part of the original design. Examples are stained glass, original colour in applied decoration, drawings which show the designer's colour scheme, and structural elements of different materials, both external and internal. In available daylight, interior photography with colour is practical only where the level of illumination is high and of an even quality. Long exposures will influence

the film's colour balance and light-coloured interiors may be affected by coloured, reflected light coming in through windows from any nearby grassed areas outside. Best results are obtained with additional illumination provided by artificial light sources, the most suitable being blue flashbulbs or electronic flash when using daylight colour film.

Many photographers using 35mm cameras take the sensible precaution of protecting the front element of the lens with a UV or haze filter. This should not be left on in all conditions, however, for it can prevent the fitting of a more useful filter, the polarizing filter or pola-screen. By rotating the polarizing filter in front of the lens, unwanted reflection from gloss-painted surfaces in sunlight can be minimized, allowing detail to be seen more easily; water surface reflection can be reduced; reflection from window glass can be eliminated, and the glazing bars accentuated when photographed from certain angles. Polarizing filters are an expensive accessory but their many applications make them a worthwhile investment.

Polarizing filters have known characteristics where certain reflective surfaces are concerned e.g., glass or water. They do not work in regard to uncoated metallic surfaces and sometimes not completely on gloss-painted surfaces; holding the filter up to the eye and rotating it will show the effects, if any. They sometimes produce advantageous results on stonework (see far right), cutting through the glare of a seemingly perfect surface and revealing underlying deterioration. An exposure increase of one-and-a-half to two stops is usually required with this filter.

Until images on colour film can be made as permanent as those on black-and-white film, colour photography should be carried out only as an addition to the black-and-white archival record.

The permanent image

Permanence in a negative or print can be assured only if the basic requirements of good processing are properly carried out. Residual chemical left in the emulsion will be affected by the storage conditions under which the image, negative or positive, is housed. Negatives should be stored in individual envelopes, preferably with side seams, but where the seam is central it should contact the base material and not the emulsion of the film. The surfaces of a negative should not be touched. Fingers leave a thin layer of perspiration to which dust will stick. The negative should be handled by its edges and never be placed emulsion-side down on a surface over which it can slide and be abraded. High relative humidity damages both black-and-white and colour materials. Cardboard or wooden containers should be avoided. BS 5687: 1979 4.3. containers should preferably be of anodized aluminium, stainless steel, or steel with a baked-on inert lacquer.

Each individual negative, or strip of negatives, should be kept in a separate envelope called an 'inner' which is usually transparent. Ideally it is then placed in a stout card envelope, an 'outer'. Both must be of good quality so that their contents should not be harmed. These envelopes are then filed, in sequence, in a sturdy container so that they can be inserted and extracted without force. The container should preferably be of metal, coated with an inert finish. Timber, poor-quality cardboard, and some paints and varnishes have a long-term deteriorating effect on the gelatin-based negative and transparency.

Colour transparencies are vulnerable to the same harmful agents that affect black-and-white negatives but, because the transparency is the camera image and final record, extra precautions are necessary. Synthetic dyes fade so exposure to bright light (including projection) should be restricted to the essential. Duplicate transparencies, made either at the time of the initial recording or by copying later, are a simple way of prolonging the period of existence of an image. As colour transparency emulsion is hygroscopic, care must be taken to avoid mounting or storage procedures that might introduce moisture. Even breathing on cover glasses to clean them is suspect.

Finally, the permanent image accessioned into the archive must be adequately captioned, dated, and given some form of consecutive numbering to facilitate its easy retrieval. Dating of the image is important, for not only does it place the subject matter within an historical context, but it also indicates when periodic checks of the film's physical condition will be necessary.

Photography in the field

Agricultural buildings

The interiors of barns are rarely illuminated by artificial light; they are often of timber construction and only poorly reflect the usually limited amounts of available light. In smaller barns, the lower part of the interior may be lit adequately if the large access doors can be opened; but the illumination of the roof structure, which only receives light reflected upwards from the floor area, can be a problem. The most satisfactory method of obtaining an even exposure with such difficult lighting is to use a combination of available daylight and flash-lighting directed towards the roof. In practice, the exposure may be long enough for the flashgun to be fired from separate positions while being pointed towards the roof area.

If the flashgun is hidden from camera view while being fired, the operator can walk freely in front of the camera's open shutter without being recorded on the film. If constructional details are to be recorded by using only the available daylight, the exposure time should be multiplied by four to take account of the low reflective quality of old timbers.

In small cruck-framed barns the wide-angle lens should be used to record a complete cruck truss in one photograph. If this is not possible, two exposures can be made from the same position; if each is on either side of an imaginary central line through the truss, the prints can be joined to give a wide-angle effect.

Industrial buildings

Industrial buildings are best visited with persons having specialist knowledge of the relevant production techniques who can convey particular information for the benefit of the photographer, enabling him to record the material in the most appropriate ways.

Many industrial buildings are no more than protective covers for the processes that go on inside them. The machinery and its arrangement will therefore be the more important aspects of the photographic recording. The exterior of the building should be photographed with whatever evidence that

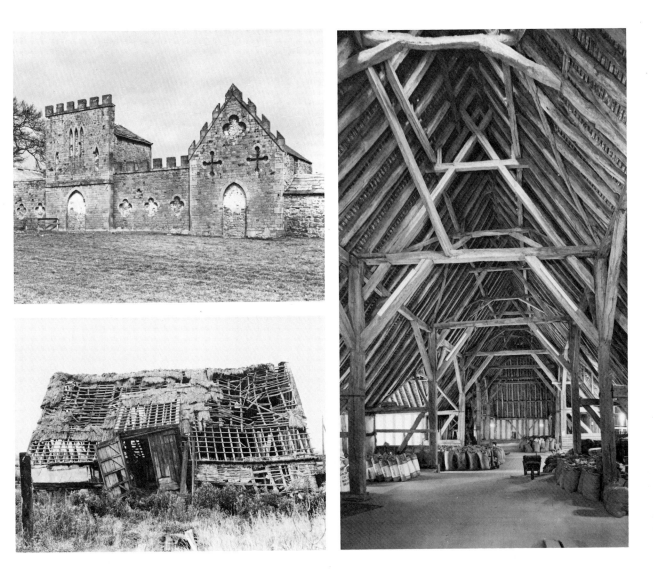

Farmers usually require every available building for storage of crops or shelter for animals. Continuous and necessary uses have thus preserved many old buildings on farms, but pressure of modernization can mean destruction, and the oldest buildings are often the first to go. Even if not demolished, they can be left to dereliction. Recording the buildings of the farm is a particularly urgent need.

remains of allied structures related to, for example, the receipt and despatch of materials. Any existing machinery and cast-iron or timber constructional features should be photographed in detail, including makers' names and identification marks. Camera viewpoints should be chosen to show the sequence of operation for the processes involved, and a wide-angled lens should also be used to record maximum information where conditions are cramped. A prime aim in the photography — for instance in showing the accurate location of openings, doors and chutes — will be met by showing an entire elevation straight on. Vertical or horizontal scales may be introduced to aid in the subsequent production of drawings from which complex industrial operations can be better understood.

Existing industrial structures can retain evidence of older techniques in the type of machinery used or in the way in which machines were operated. In such cases, stages of the process should be photographed with the machine or machines in operation. One seemingly simple procedure could be a vital clue about the method of operation of much older machinery. The photographic record should show the operator at a critical point in the process but positioned where the machinery can be clearly seen. If one man spends all day pushing the product

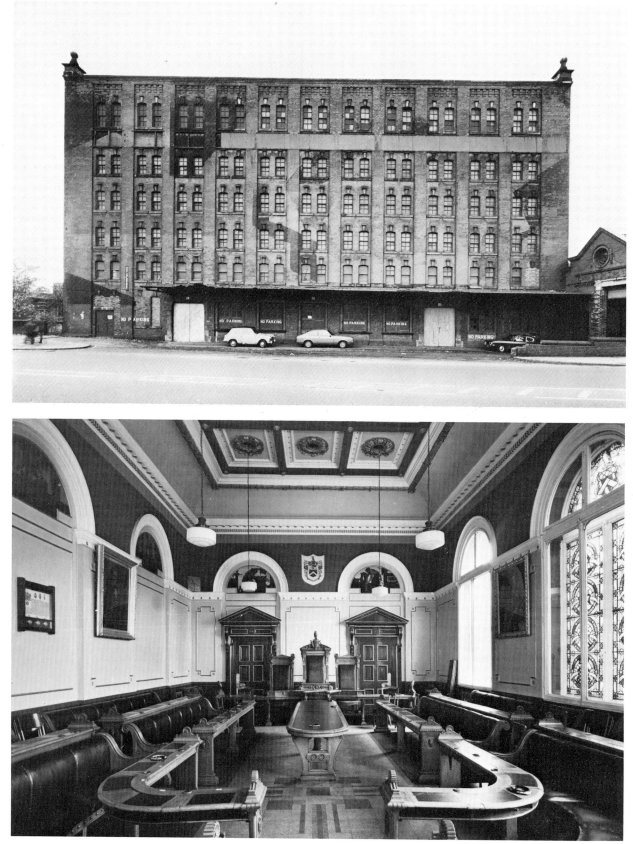

Industrial buildings can range from one compact structure to a rambling complex group. It is often difficult to judge the scale of a building in a photograph but this can be given to straight-on elevations by the inclusion of a figure or familiar object such as a car. Permission for access is usually difficult to obtain not least because of the possible dangers in buildings intended for industrial processes. It is important, therefore, that external photographs show maximum information.

between operators, then photograph this too, for his job is important in understanding the work flow and the relationship between the machines. In recording this sort of material, full documentation, including written descriptions of what is happening, is as important as the photography itself.

Public buildings

Public buildings take many forms, depending on their function and period of construction. Often impressive in appearance and symmetrical in design, each one has to be photographed in a way that will best show its most distinctive external features. Straight-on, overall external views should be taken in addition to details of windows, doors and decorative features. Internally, the staircase and its setting, the entrance hall, and any principal rooms should be photographed. Where all rooms are similar in appearance, coverage of one typical room will suffice; one example of each of the typical fittings as a detail will also be required. Fireplaces, built-in cupboards, doorcases and window surrounds should be lit to show decoration and moulding in relief.

Bridges

Bridges are a part of the architectural landscape particularly at risk as more roads are widened and altered to suit modern conditions. The most informative photographs of a bridge, and usually those most difficult to achieve, are ones taken from a central viewpoint directly towards each of the sidelong elevations. Details showing the main structure supporting the carriageway and connecting spans, particularly if they contain a date-stone or boundary mark, should also be recorded. A telephoto lens will be useful here.

Essentially public buildings — the town hall, concert hall, market house, customs house — are places of congregation. More often than not they have distinguished exteriors and large and decorative interiors. The problem in photographing this type of building is the continuous movement of people. Enquiries should be made to find the quietest periods when the least inconvenience will be caused to both people and photographer.

If a bridge has been widened, evidence of both the widening and of the bridge's earlier form may show on the undersides of the arches. The parapet is usually the most vulnerable part of a bridge and any parapet or ironwork handrail that remains should be recorded both in general view and in detail. Any buildings on the approaches to the bridge that form part of the complex should be photographed. Original fittings or machinery directly associated with the operation of an opening bridge will need detailed coverage in the same way as the machinery of industrial buildings.

Churches

The exterior photographs of a church should be taken from viewpoints which best relate each part to the whole, enabling an assessment of development where this extends through several centuries. At least one photograph should show the church in its immediate setting, with possibly another more distant view to show its relationship to the landscape. Inside, the basic internal requirements are to photograph views from each end of the nave, looking into the chancel and the altar position. A church may have many internal fittings of which a photographic record should be made, e.g., font, pulpit, monuments, lectern, brasses, pews, stained glass. It may also have items relating to local history; hatchments of arms, or old photographs hanging in the vestry.

Photography is a more responsible way of recording church brasses than rubbing with crayon over paper since brass can be irretrievably damaged by the cumulative effects of abrasion.

The written record accompanying photographic negatives and prints is essential and *must* include certain information. Without this the photographic record is almost meaningless. It should become a matter of habit to record in the notebook immediately after recording with the camera. Any time lapse could result in omission or inaccuracy without the opportunity to correct it: e.g., the building might have been demolished.

CHECK LIST OF INFORMATION FOR PHOTOGRAPHIC RECORDS

Location

County: Usually easily defined, but care should be taken when the building is on or near the boundary between two counties.

Civil parish: Often difficult to establish: even local knowledge may be misleading though the local reference library should know, and the planning authority for the area will probably be able to help. If the building is 'listed' by the Department of the Environment, then the civil parish should be indicated in the entry. Ordnance Survey 1:100 000 England Administrative County Maps outline and name civil parishes.

Building-site name: A postal number, and possibly a name, together with a street name will locate the site.

National Grid Reference: Information on how to read this is shown on the recommended 1:50 000 Ordnance Survey maps. The result will be a six-figure number giving a precise location.

Details of negative or print

The following additional information will locate the subject matter exactly in relation to the building and should be included.
a. Which side of the building is it: north, south, east or west?
b. Which floor is it: ground, first, second, roof, or in the basement?
c. Where is the room: at the east or west end of the building, or is it at the north-east corner?
d. Where was the viewpoint: the north side, or the north-west corner?

Cataloguing details

Photographer: Name in full, and printed in block capitals.

Date taken: If the photographic survey has been made over a period of time all dates should be recorded.

Negative reference number: In archive a negative will be given its own accession number to ensure easy retrieval and file-card identification. The photographer's own individual numbering system should follow the photographic sequence. A prefix can identify negatives of the same subject.

The more information you can give, the more valuable will your photographs, as historical documents.

Finally, notes of your exposure time, aperture and lighting will enable you to check where things went wrong. If everything went right, then they will assist you when you next encounter a similar subject.

Keeping a record

Whenever photographs of architecture are formed into collections, some buildings that are architecturally interesting are historically of little value simply because the subject cannot be identified. One explanation could be that any written record made when the photograph was taken has not remained with the negative or print. It is vitally important that written detailed information of identification is made at the time of photography and that this is put securely with the negative and its prints as soon as possible. A photographic record of an historic building is only as good as its written documentation.

Copyright

The law on copyright is extremely complex. Basically, the copyright of photographs taken of buildings with personal equipment and materials belongs to the photographer (except in the case of a professional photographer working in his employers' time). The main difficulties arise when copying old photographs or drawings. If the original material being copied is more than fifty years old it is technically out of copyright; provided, therefore, that the owner's permission has been obtained, the photographer is free to make a copy-negative. If, however, the material to be photographed is less than fifty years old, then it is still someone's copyright. In practice this may be difficult to discover, because ownership of the original does not necessarily confer copyright. However, the law allows one copy print to be made for reference or record purposes and in most cases this will suffice.

Conclusion

Photography alone does not produce the definitive record and is not the only visual medium of recording. The drawn image, whether the result of direct measurement or the trained artistic eye, is an important addition. Photogrammetry is directly related to photography because a very precise elevational drawing can be plotted from a co-ordinated pair of photographic negatives.

A photograph of architecture can never be the final record as buildings may be altered and changed. Photographic Recording is one discipline in a multi-disciplinary field. If you find something that you feel is important, photograph it, but also tell the local architectural study group of it and get it measured and drawn. Then make sure the record, including your photographs, is carefully labelled and deposited safely where others can use it; for if it is part of our history, we all want to know about it and so will our successors.

Selected reading

B. BISHOP, *How to Photograph Buildings in Black-and-White and Colour*. Fountain Press 1956.

A. BONI (ED.), *Photographic Literature*, 2 vols. Morgan & Morgan 1962, 1972.

B. BRACEGIRDLE, *Photography for Books and Reports*. David & Charles 1970.

B. BRACEGIRDLE, 'Photography for Industrial Archaeology' in N. Cossons and K. Hudson (eds.), *Industrial Archaeologists' Guide 1971–3*, 157–71. David & Charles 1971.

R. C. CLEVELAND, *Architectural Photography of Houses*. F.W. Dodge Corporation 1953.

V. M. CONLON, *Camera Techniques in Archaeology*. John Baker 1973.

M. B. COOKSON, *Photography for Archaeologists*. Max Parrish 1954.

R. DALLAS, 'Surveying with a Camera. Photogrammetry', *Architects Journal* 171, No.5, 1980, 245–55.

R. DALLAS, 'Surveying with a Camera. Rectified Photography', *Architects Journal* 171, No.8, 1980, 395–9.

E. DE MARÉ, *Architectural Photography*. B. T. Batsford Ltd. 1975.

E. DE MARÉ, *Photography and Architecture*. Architectural Press 1961.

R. M. FANSTONE, *All about Architecture and your Camera*. Focal Press 1946.

H. GERNSHEIM, *Focus on Architecture and Sculpture*. Fountain Press 1949.

J. GIEBELHAUSEN, *Architectural Photography*. Nikolaus Karpf 1965, English-Language Edition.

M. F. HARKER, *Photographing Architecture*. Fountain Press 1951.

Life Library of Photography. Caring for Photographs. Time-Life Books 1978, English Edition.

H. J. MCKEE, *Recording Historic Buildings*. U.S. Department of the Interior 1970.

L. A. MANNHEIM (ED.), *Focal Encyclopaedia of Photography*. Focal Press 1978, Desk Edition.

S. K. MATTHEWS, *Photography in Archaeology and Art*. John Baker 1973.

G. A. T. MIDDLETON, *Architectural Photography*. Hazell, Watson and Viney 1898.

PETERSEN'S *Architectural Photography*. Petersen Publishing Company 1973.

G. QUICK, 'The Photography of Relief Carvings', *The Photographic Journal*, June 1975, 272–7.

L. SHAW, *Architectural Photography*. Newnes 1949.

J. SHULMAN, *Photographing Architecture and Interiors*. Watson-Guptill Publications 1962.

J. SHULMAN, *The Photography of Architecture and Design*. The Architectural Press Ltd. 1977, British Edition.

H. C. SIMMONS, *Archaeological Photography*. University of London Press Ltd. 1969.

J. VELTRI, *Architectural Photography*. Amphoto 1974.

Finsbury Public Library, 245 St. Johns Street, London EC1, has a major collection of books on photography as part of a subject specialization scheme.

Among many books on buildings and their history, introductions which would be useful to photographers are:

R. HARRIS, *Discovering Timber-Framed Buildings*. Shire Publications Ltd. 1978.

P. KIDSON, P. MURRAY, P. THOMPSON, *A History of English Architecture*. Penguin 1969.

R. W. MCDOWALL, *Recording old houses: a guide*. Council for British Archaeology 1980.

TECHNIQUES

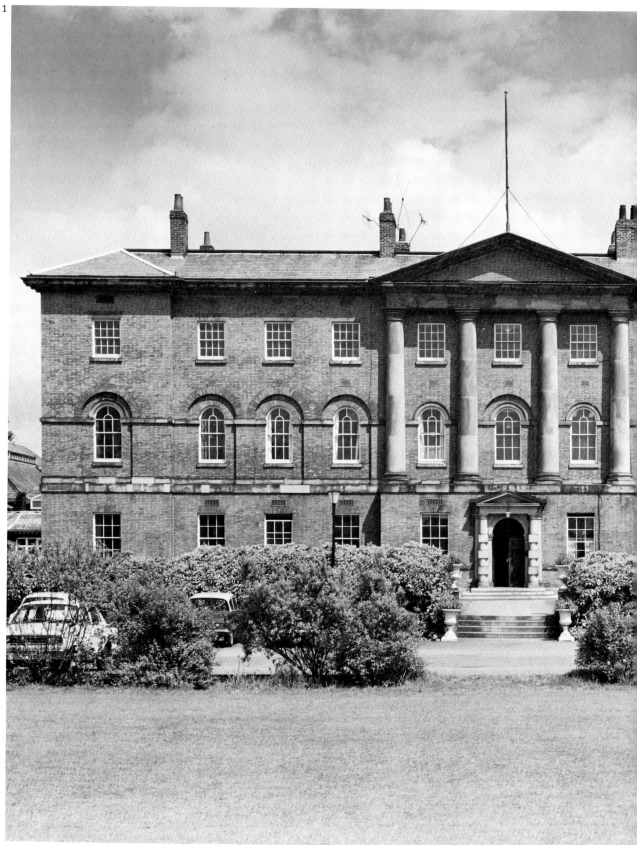

EXTERIORS

Approach to subject

The purpose of record photography is to convey as much information as possible to the person viewing the photograph. This information must be given in a simple and direct way (1). Information may be obscured in a photograph which attempts to convey atmosphere (2), or distorted in one taken to express artistry (3), though neither need be exclusive.

Take time and trouble, even with the plainest looking exteriors. Carefully photographed elevations can, to the experienced eye, give clues to the original or present internal room arrangement. Make it clear; keep it simple.

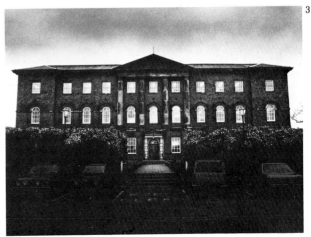

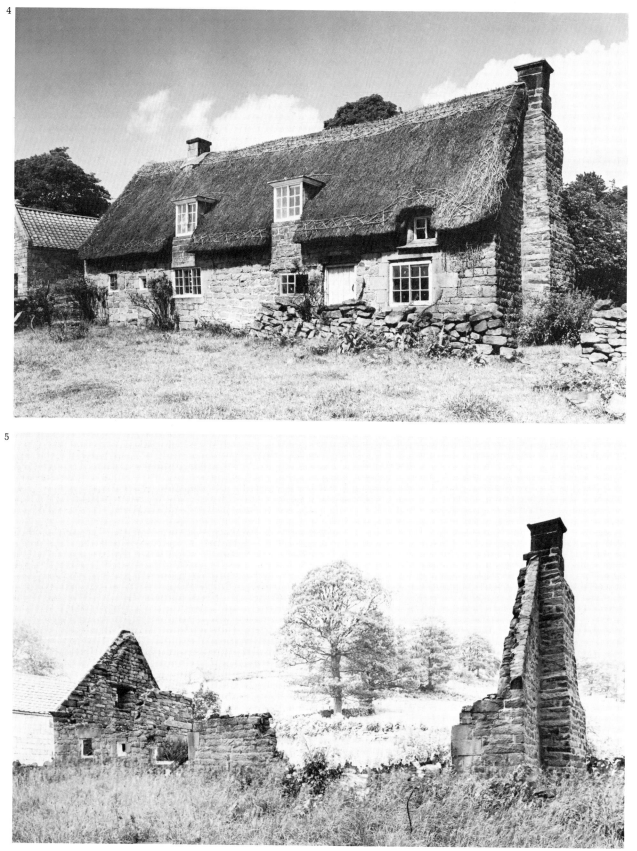

Recording for posterity

An attractive and architecturally interesting cottage photographed in 1977 (4). By 1980, even as a ruin, it retained details worthy of record (5); but without the earlier photograph that later record would have been markedly less informative.

A record of this derelict house (6) would include, as well as general elevations, such obvious details as the doorcase and pediment (7). In the subdued lighting of an overcast day a dated lintel was given reduced exposure and increased development to enhance contrast in the incised lettering and numerals (8). A general view of the interior shows the fireplace as well as the original position of the ceiling (9).

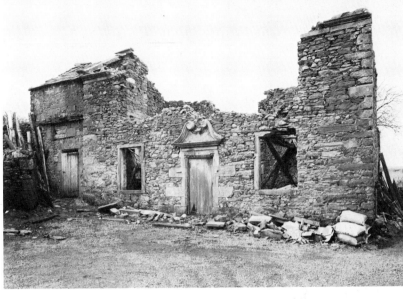

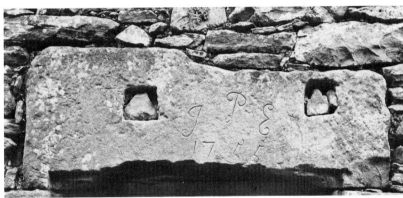

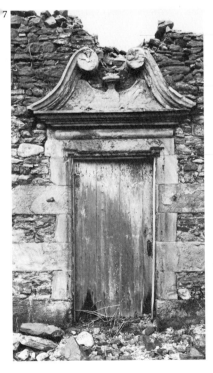

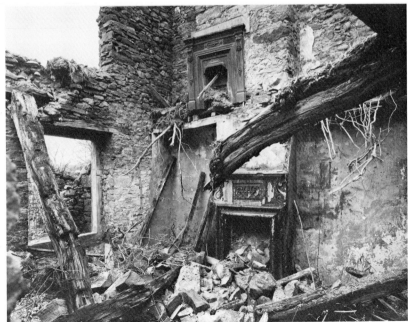

Unexpected discovery

Although this building looked unimpressive and uninviting (10), the discovery of a date-stone over the doorway (11) prompted a request for permission to enter. This was fully justified when the light from a powerful torch in the totally dark building revealed the interior. Flash-lighting was then used to record delicate plasterwork and a carved stone fireplace (12).

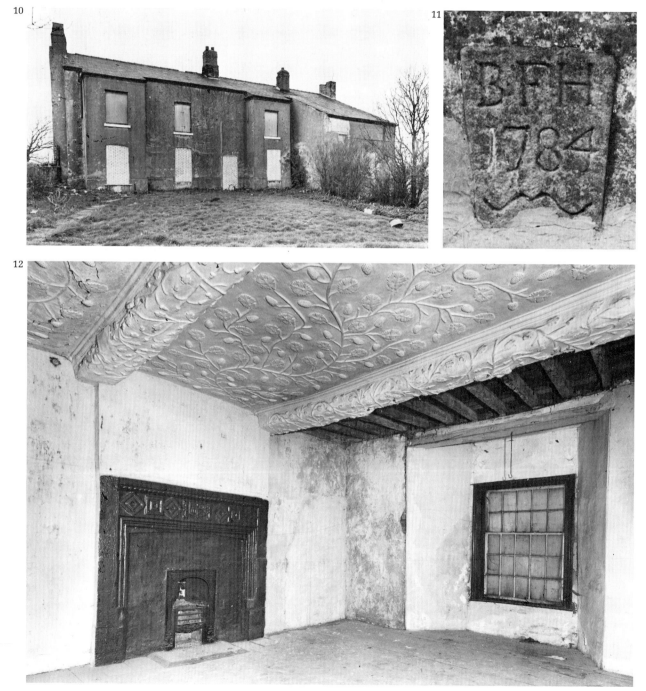

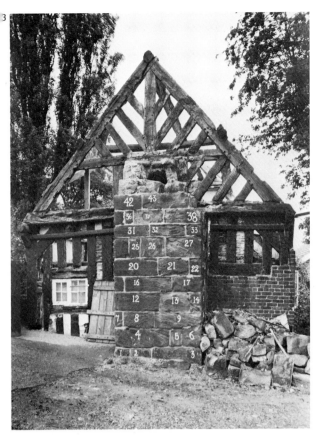

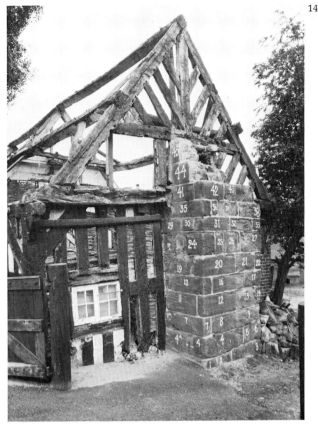

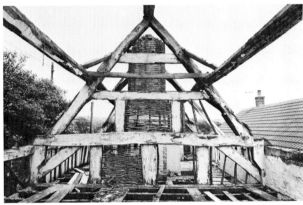

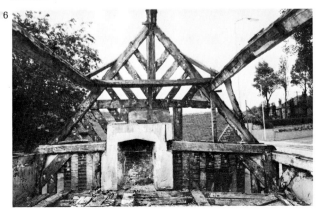

Recording for reconstruction

If a building is being dismantled carefully and reconstruction is contemplated, progress photographs taken from the same viewpoints at regular intervals can be useful (13). Structural evidence that is normally hidden behind partitions or walls may come to light only to be hidden again or destroyed very quickly.

Although alternative views can be of great help (14), viewpoints that might be in deep shadow on one visit and in bright sunlight on another should be avoided.

Once the roof is removed, a wide-angle lens will enable the recording of each truss (15). A cloudy but bright daylight will prevent lighting problems when both sides of each truss are to be photographed. Where the timbers have been identified with letters or numbers (16), exposure should be kept to a minimum to avoid those on light backgrounds being lost in the density of over-exposure.

Relating buildings to environment

Where buildings form part of a complex, at least one photograph should show the whole arrangement (17). Buildings should be shown in relationship to the surrounding landscape where they are influenced by or have an effect on it (18). Land-scape might provide higher vantage points from which to show the sub-ject (19). Industrial or working build-ings should be related to each other and to the element of motive power such as water (20). In a barren landscape, a figure included in the photograph provides a familiar fea-ture to indicate scale (21). By photo-graphing with side-light, taking care to shield the lens and prevent flare, buildings will be separated from the landscape and appear more prominent (22).

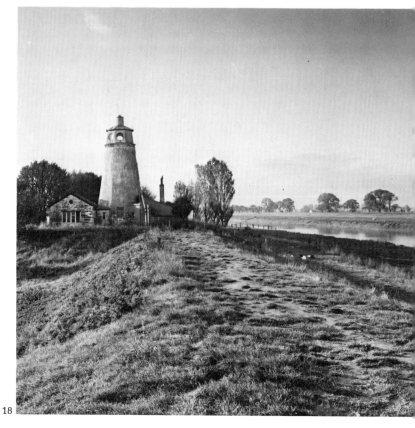

18

23

24

25

Choice of viewpoint

Choice of viewpoint is an important consider-
ation for every elevation. A straight-on view of
this house (23) would not show a gable profile
which differs from the normal roof shape; a
slightly-angled view shows the gable projection
above the roof line. With industrial buildings a
straight-on viewpoint is essential to show the
related positions of all openings (24).

If a viewpoint is too elevated, it may show the
layout but the proportional relationships within
the elevation are lost (25). Height, gained by
photographing from the first-floor window of
any building opposite, will reduce obstruction
by foreground objects, e.g. railings, and prevent
convergence of verticals (26). Where the fore-
ground object is of similar material to that of the
elevation, attempts should be made to establish
the base-line of the building by gaining height
(27).

26

27

Choice of viewpoint and lens

The greater depth of field obtained with a wide-angle lens enables the main structure in any group to be related to foreground interest (28). The structure may be photographed on its own, or as the dominant subject where there is also background interest (29).

Although proximity to a subject enables structural elements to be shown more clearly (30), each part appears in better architectural proportion by moving the camera away and using a telephoto lens (31).

This subject, photographed from the same camera position, will have similar image perspective even if different focal length lenses are used (A:100mm; B:50mm).

Moving the camera position nearer to or further from the subject to obtain the same image size on the negative with different focal length lenses will alter the image perspective (C: 50mm; D: 28mm).

Panoramic views

Where sufficient distance is possible between camera
and subject, panoramic views can tell a more complete
story of the relationship of a building with its surround-
ings (32).

 The camera must be set on a tripod and it must be
levelled accurately. By moving the camera in an arc
(see diagram below), with each area of view over-
lapping the previous one, a series of exposures is made
(33). The resulting prints are cut along the edge and
placed over each other, in sequence, to give the
panorama (34). Once accurately aligned, they can be
cut straight across through the overlapping sections,
and butt-mounted on a sheet of card.

 An effective panorama can be made with just two or
three exposures (35). The lighting on the subject, and
therefore the exposure, must remain constant for the
whole series of photographs. This prevents compli-
cations during printing in eliminating uneven sky
tones between adjacent prints.

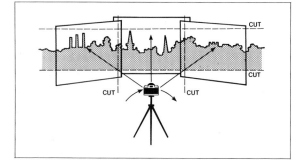

33

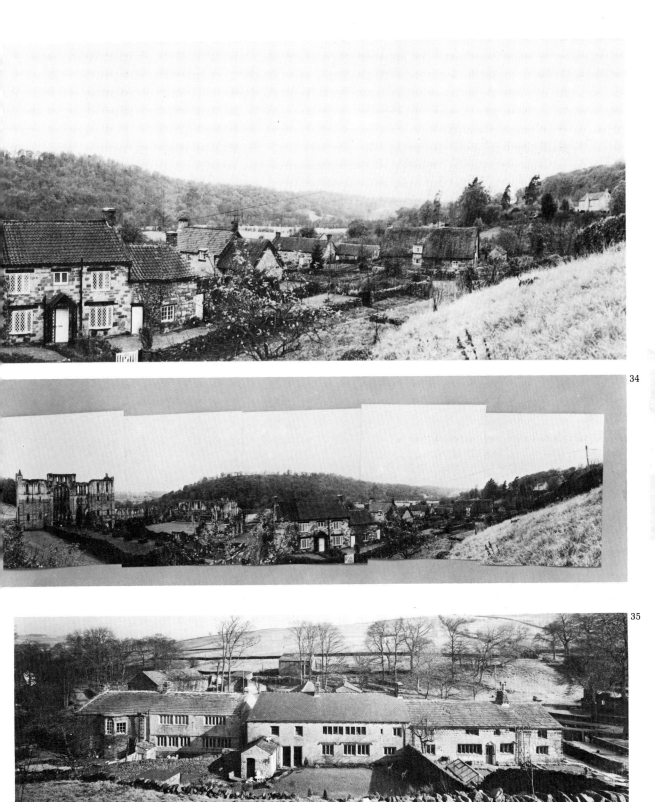

34

35

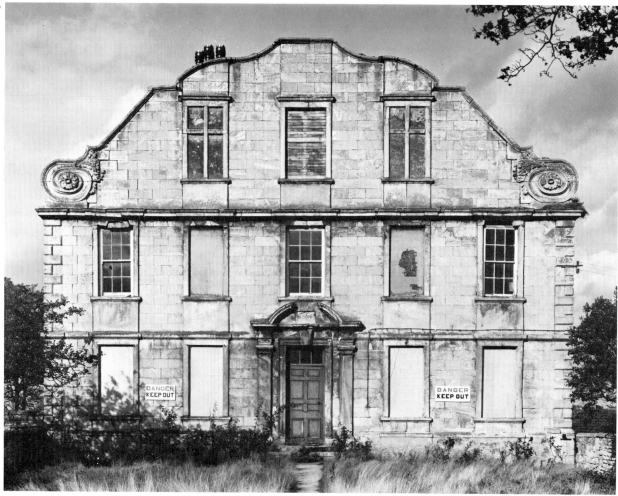

Use of natural light for exteriors

Where an elevation has decoration (36) or is constructed of different building materials (37), raking sunlight at too acute an angle to the plane of the surfaces can cause exposure problems and give excessive contrast. The best lighting is provided for a straight-on view when the sun is approximately 45° between the axis of the lens and the plane of the elevation (38, 39). Acutely-angled raking light, 'side-light' is appropriate when the camera is moved close to obtain a detail of part of the elevation.

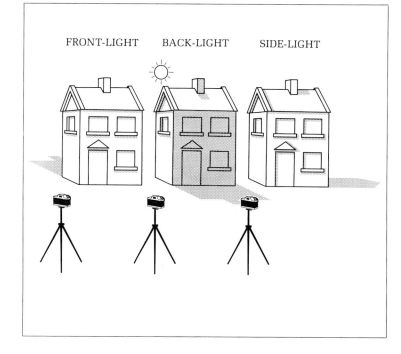

FRONT-LIGHT BACK-LIGHT SIDE-LIGHT

Features become more pronounced when their shadow is projected forwards by light coming from in front of and towards the camera (40). This lighting effect is usually termed 'back-light'. Normal exposure and development in such cases will produce too 'contrasty' an effect in which shadow detail will be lost. Giving more exposure than that indicated by the exposure meter and reducing development will produce a negative of controllable printing contrast.

Using 'front-light' and photographing straight-on to a subject (41) is essential where a reconstructive drawing is to be made. This allows all detail to be seen without the confusion that might be caused by lengthy shadows.

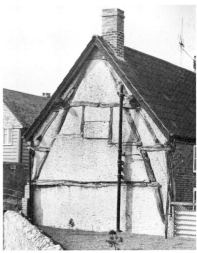

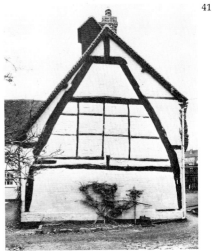

Difficult lighting situations

Lighting by sun either from the side or from in front of the camera, is desirable for depressions (42); they may become 'flattened' if lit by sunlight from behind the camera.

Where the sides of the depression are steep and sunlight may produce a 'black hole' effect, a cloudy but bright sky will provide more favourable lighting (43). Exposing for slightly less than the meter reading and increasing film development will produce a negative of acceptable contrast.

On an upstanding rounded subject, a light coming from in front of and towards the camera produces good modelling (44). Sunlight at an acute angle is reflected with great intensity from surfaces in the highlight areas, producing an above-average range of contrast. This can be effectively controlled by taking an exposure meter reading from the highlight and shadow areas, setting the exposure between the two and slightly reducing the development time.

43

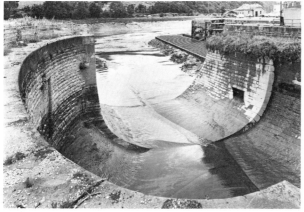

44

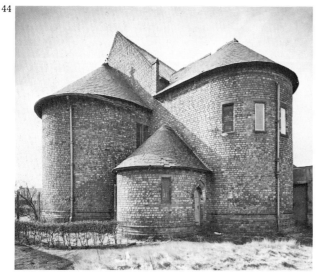

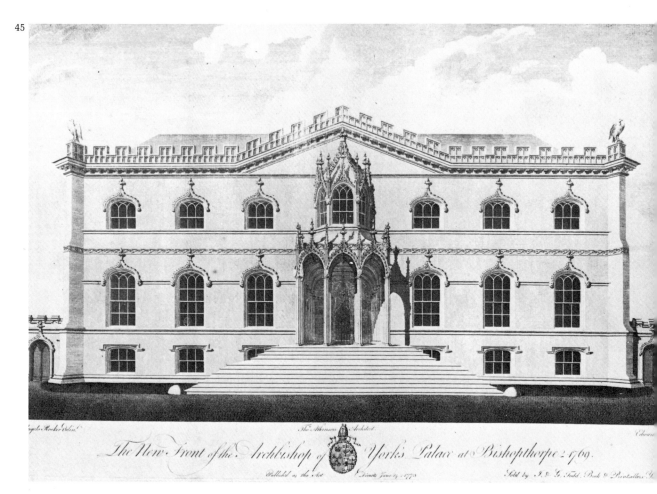

The New Front of the Archbishop of York's Palace at Bishopthorpe 1769.

Matching architectural elevations and copying drawings

An architectural measured drawing shows an elevation in true proportion (45). To obtain a similar effect for the straight-on photographic record of the building the camera should be some distance from that elevation (46). The ideal viewpoint is as near central to it as possible, both laterally and vertically. If the camera is too near the elevation and too low, the roof-line for instance, being set back, will not be correctly represented.

Successful copying of drawings themselves can be done under makeshift conditions, though care must be taken to avoid tripod legs and their shadow obscuring parts of

a copy subject. It may, for instance, be possible to create a firm support by pushing one leg of a lightweight tripod into a partly-closed drawer with the other two legs resting against the lower part of the piece of furniture by the weight of the camera (47).

If backed by a sheet of black paper, copy subjects on thin white paper or having print 'see through' will be improved in contrast (48). A single-lens reflex camera will be correctly positioned if directly reflected in a flat-backed mirror placed horizontally at the centre of a copy subject (49).

47

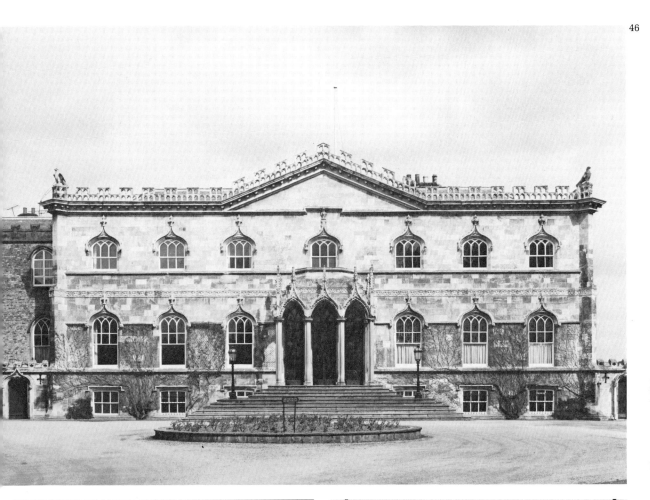

48

49

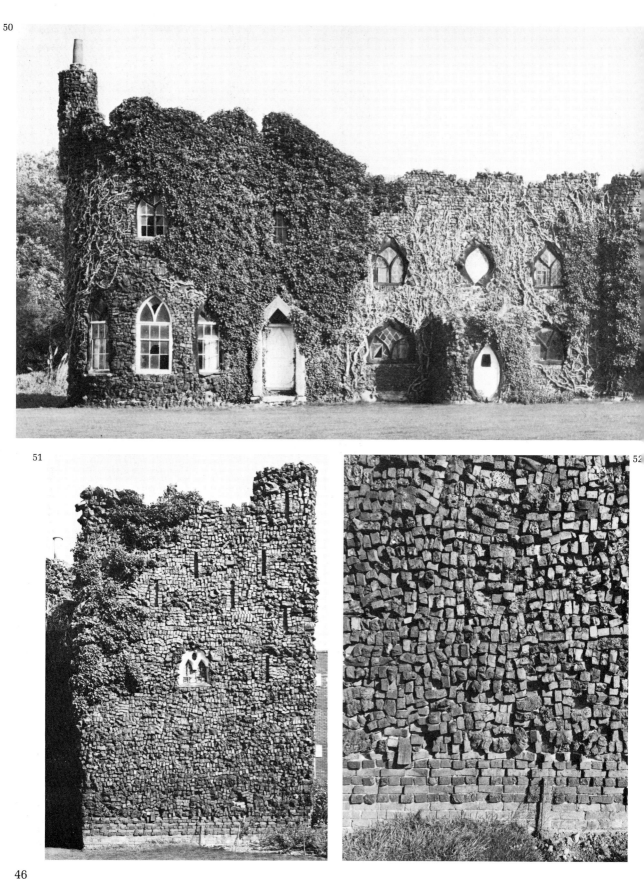

50

51

52

46

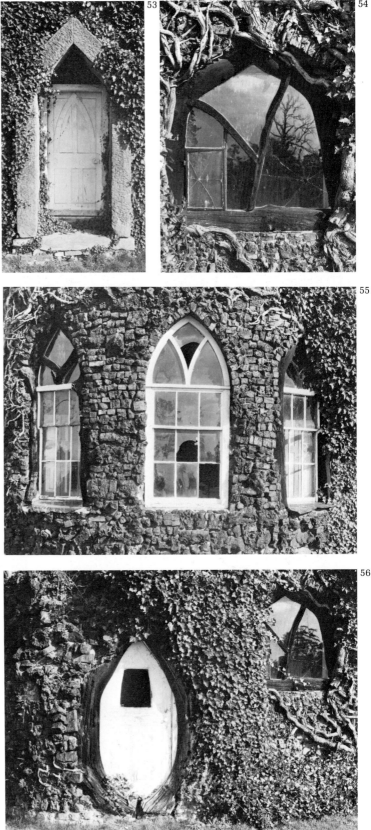

Moving in closer

Once the general view of a building (50) has been taken, a portion of it can be selected for detailed recording either by moving the camera closer or by using a telephoto lens (51). The two are complementary: a photograph showing a detail of random brickwork (52), for instance, would be meaningless without one relating it to the whole elevation. Sunlight at 45°, or slightly less, to the plane of the subject is essential for photographing an elevation of such textural quality. Indeed, most elevations, even very plain ones, have details worthy of record. The differences in style of features such as doorcases (53, 56), windows (54, 55) are enough to require a photograph of each.

57

58

59

60

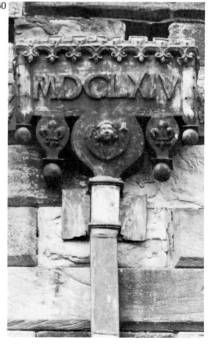

Contrast and exposure determination

A number of features of differing brightness, side by side, may be recorded on one photograph by increasing exposure and reducing development to prevent excessive contrast (57). If they are of similar brightness but have different textures, this will be emphasized by reducing exposure and increasing development to improve contrast (58).

The telephoto lens is ideal for detailed views but black-and-white film has an advantage here in that, providing the image is sharp, part of the negative can still be enlarged for closer inspection (59, 60).

Where the camera is pointed towards a subject on the upper part of a building, the exposure-meter reading may be influenced by the expanse of sky light (61). The reading can be taken, however, from something of the same material which is similarly lit but in a less affected area lower down on the building.

When subjects which are usually considered inaccessible can be approached on their own level (62), then the exposure reading may be made by pointing the meter receptor towards their base.

62

49

63

64

65

50

Uses of additional lighting

Where sunlight can be used to show textural differences on a building's exterior, it should always be preferred (63). When this is not possible, flash-lighting at an acute angle to the subject can produce a similar effect. Usually, under studio conditions, strong side-lighting is used to reveal incised and textural detail (64); using a similar technique on an external subject, the camera exposure should be set so that the prevailing daylight conditions do not record on the negative (65). The only light to affect the film will come from the acutely-angled flash-gun, set to its maximum output so that minimum exposure time and aperture can be used on the camera.

A combination of flash-light and daylight can be used to produce an evenly-exposed negative in which the sculptural qualities of external subjects in shadow, perhaps additionally blackened by years of air pollution, can be recorded (66). Flash-lighting in the daytime can also improve a photograph by reducing the visually disturbing effect, illustrated here, of strong shadows cast across the subject by oblique sunlight (67).

Fill-in flash technique

Flash-lighting can be used as the principal light source to increase image contrast in a subject under very dull weather conditions (68).

To calculate the distance from the subject at which the flashgun must be placed, the exposure reading is taken from the surrounding lighter area and the aperture obtained divided into the guide number for the flash source.

Use the correct synchronizing shutter speed for the camera in combination with the indicated aperture from the meter reading.

With the exposure based upon the distant day-lit area, a minimal amount of flash-light was given to the waterwheel to increase detail without destroying the total effect of dereliction (69).

Flash can be used as a 'fill-in' where the subject has obscuring shadow, produced in this case by overhanging foliage (70). To avoid loss of detail in the highlights when using this method, a meter reading is made from a bright area on the subject. The aperture indicated opposite the synchronizing shutter speed is divided into the guide number and the resulting flash subject distance increased by one-third. This is to reduce the unrealistic effect of flash-light appearing much brighter than sunlight.

Using the correct exposure for the scene on the other side of the bridge, flash-lighting was used in balance with daylight to reveal structural details in the normally deeply-shadowed underside of the bridge (71).

The mixture of flash and daylight is a valuable technique for showing detail in external situations where either flash or daylight alone does not.

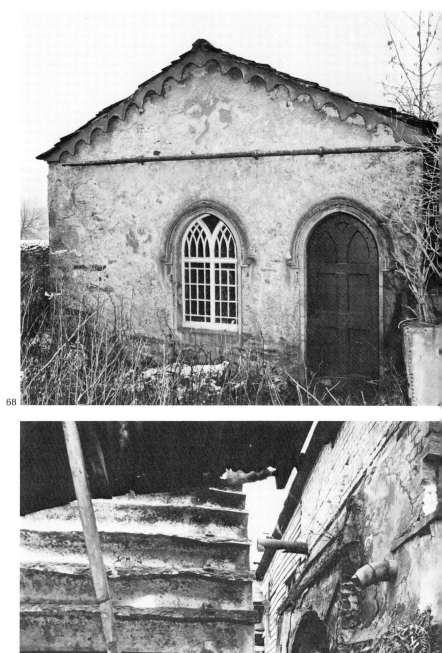

68

69

70

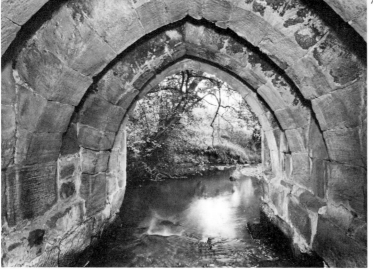

71

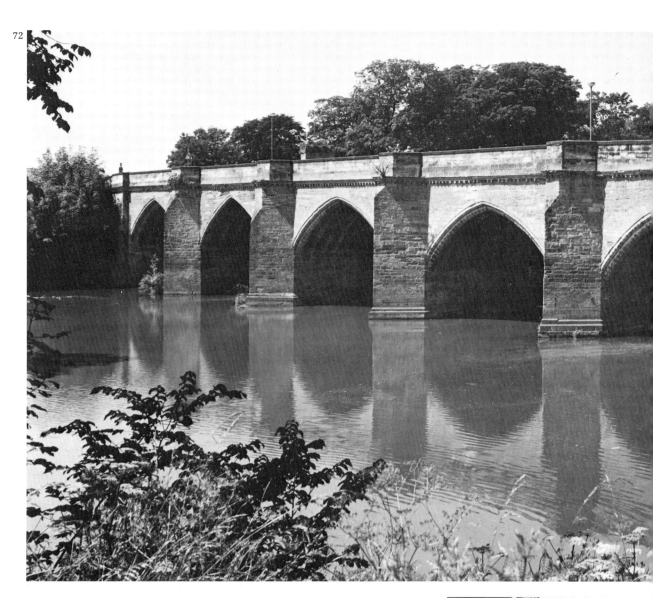

Bridges

Bridges can present particular photographic problems since the most informative viewpoint, straight-on, is not often possible. Medieval bridges pose an additional problem in how to show the projecting cutwaters to best effect. A view taken from the north bank when the shadow cast by the cutwater was the exact width of one face (72) gives more information than if the bridge had been lit by sunlight from behind the camera position. Sometimes earlier bridges are encapsulated in the existing one. The structural evidence for this, often hidden beneath the arches, should be photographed. A bridge should in any case be photographed to show the underside of its structure (73).

Details relating to the bridge, including any boundary mark, tariff board (74), or identification of ownership (75), should also be photographed.

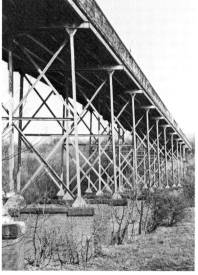

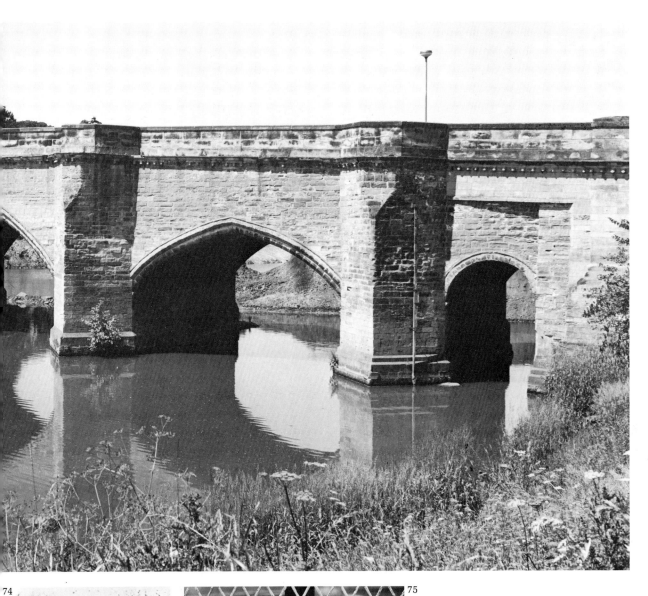

74

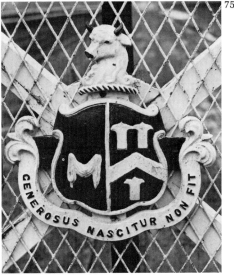

THE SALTBURN BRIDGE

This Bridge being PRIVATE PROPERTY
The Public are permitted to use it on
payment of the following Tolls for each
time of passing the Toll Collector From 6ᵗᵒ10ᵗʰ
For every Person not being in charge
of a Horse or Vehicle. One Halfpenny.
For every saddle or Led Horse, Mule or Donkey 1ᴰ

DO	Carriage drawn by one Horse	2ᴰ	
DO	DO	by two Horses	3ᴰ
DO	DO	by four Horses	6ᴰ
DO	every Cart or Waggon drawn by one Horse	2ᴰ	
DO	DO	by two Horses	3ᴰ
DO	DO	by three Horses	4ᴰ

For every Cycle or Perambulator 1ᴰ
No Vehicle carrying more than Two Tons
at one load will be permitted
to pass over this Bridge.

Mᴿˢ M.W. RINGROSE-WHARTON.

Opened September 1869. Owner.

75

CENEROSUS NASCITUR NON FIT

Examples of good exterior photography

The best examples of photographic recording of exteriors are those achieved as the result of careful and deliberate forethought. A photograph taken in winter sunlight may be the only way to obtain a view that would be partly obscured by summer foliage (76).

Choosing a telephoto lens and using the smallest aperture enables two separate elements to be related one to the other while, at the same time, producing a sufficient depth of field (77).

Projections on a red-brick elevation, normally flattened in shadow, are given relief by waiting for side-lighting from late-evening sunlight (78).

A very good example: careful control of contrast by accurate exposure and correct development; a viewpoint showing important features, the chimney-stack and the angle of the gable, and the location of the building in its surroundings (79).

76

77

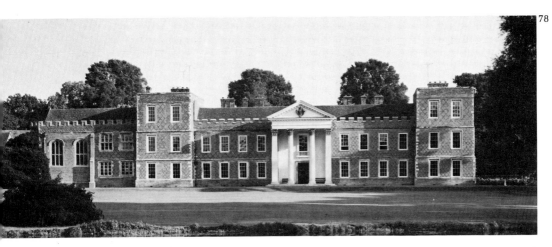

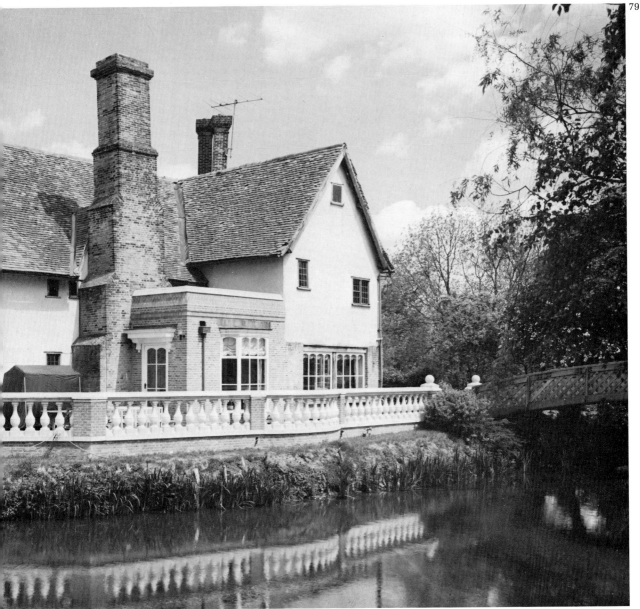

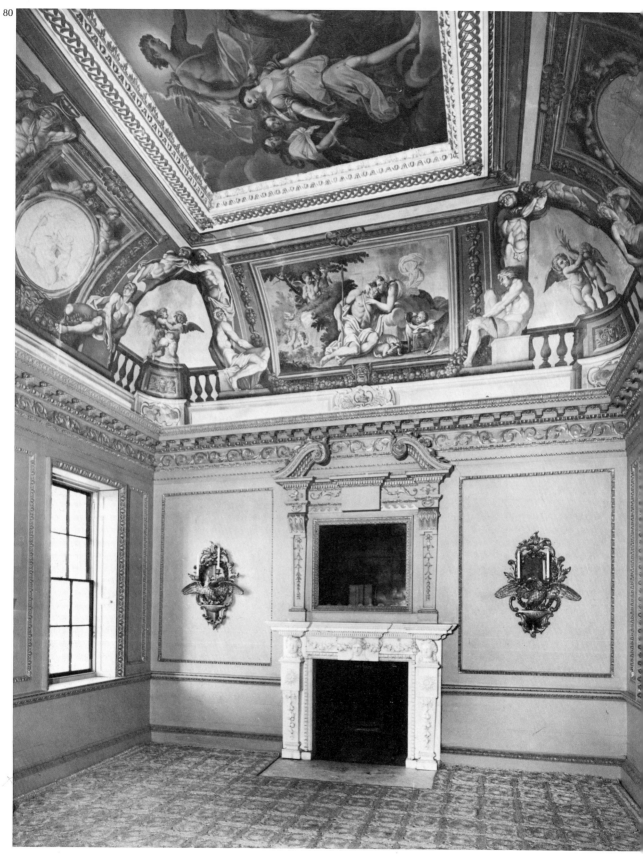

INTERIORS

Approach to lighting

The space occupied by a building is normally divided into a series of cubes most of which are illuminated by daylight through windows. This daylight illumination is frequently inadequate for photography of interiors, and so additional artificial lighting has to be used. 'Architectural photography' is a general term to describe the photographing of buildings, but here our technique, 'architectural photographic recording', is so much more. It implies that maximum informative detail of this subject is seen in all areas of the photograph (80).

Using available light to give the atmosphere of an interior (81) and straightforward representation to show what the eye sees naturally (82) produces interesting photographs but not good 'records'.

Artificial lighting, in this case flash-light, and available light have combined to produce an adequate record photograph, as well as retaining natural atmosphere (83).

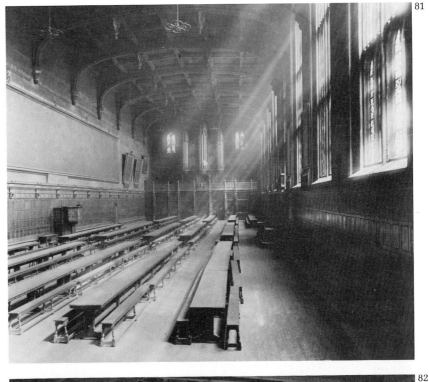

81

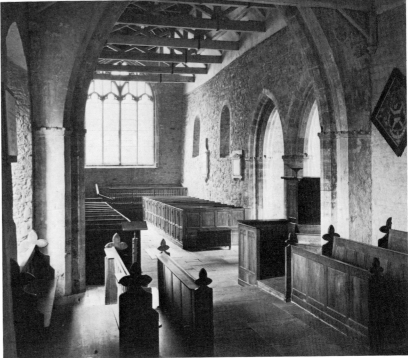

82

83

Passageways

Passageways and their location within early houses provide important clues for the historian in understanding the development of house types. It is necessary to show the relationship between passageway and internal and external doorways. The straight-on photograph of the front elevation will show the position of the entrance doorway; internally, we must use lighting and sensitive camera positions to complete the information, normally using a wide-angle lens.

The camera was placed outside the building for this view, showing a screens passage with an external door at each end (84). The camera shutter was set on delayed action, with an exposure time of one second, and the photographer with flashgun was hidden behind the nearer door. Immediately the shutter was heard to open at the end of the delay period, the flash was fired by hand. A simple alternative would have been to connect a synchronizing cable, fed through at the least obtrusive point at the bottom left of the door opening.

Another photograph was taken to show the openings leading from the same passageway (85). A mixture of daylight and flash produced a result difficult to obtain by the use of either daylight or flash alone. An overall exposure reading was taken for the naturally-lit room and increased by four times. The screens passage was lit by flash-light bounced from the white area above the camera during the period of exposure.

To prevent a black void when the subject of a photograph is an internal open doorway, lighting should also be placed in the adjacent room.

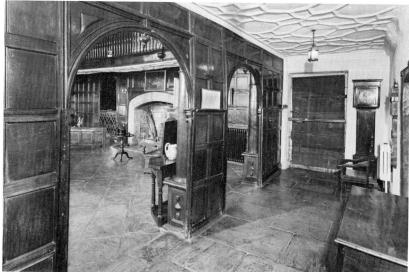

85

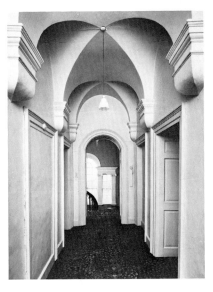

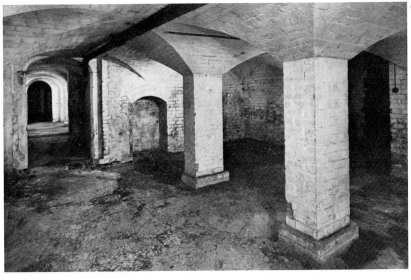

In a passageway painted entirely white, window light, or very diffuse artificial lighting, from behind the camera position will retain natural modelling (86). Direct artificial lighting would overlight the foreground and create exposure problems, as well as flattening the modelling given by natural shadow. Exposure is double that taken from a white card held at a position halfway along the passage.

Where a passageway becomes an open walkway, lighting can sometimes be used to give depth and modelling in normally dark areas where suitable obstructions can hide the flashgun that is being fired during a period of long exposure (87).

A view from a passageway looking through open doors into two rooms allows most of the lighting to be placed within those rooms (88).

An access passageway to horse stalls: the exposure was based on the available light from windows along one side, the metered exposure time being doubled. The lighting was boosted with flash-light pointed into the stalls, one flash from the camera position and two from along the wall on the right (89).

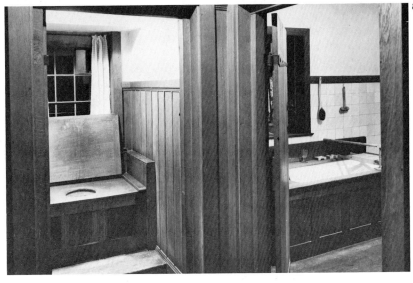

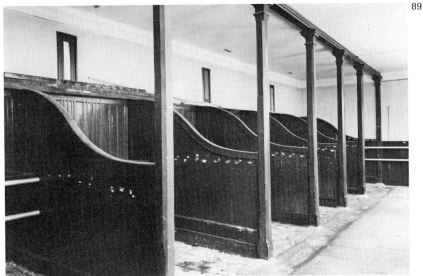

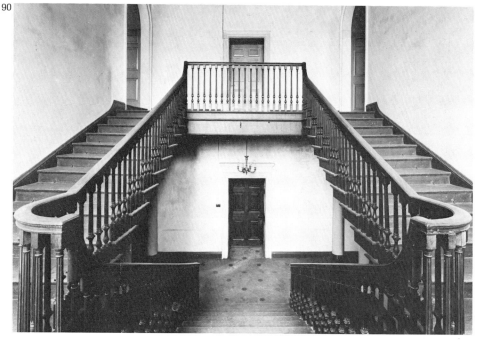

Staircases

A straight-on architectural view-point shows balusters in profile and clearly relates the various levels of a staircase (90). Looking down on the staircase produces an interesting but inadequate photographic record in which very little architectural information is shown (91).

The simple straightforward photograph usually contains most information. Because of a high level of daylight illumination, with its correspondingly short exposure time, flashguns fired by a slave unit had to be placed so as to light the darker areas of this staircase (92). The flash fired at the foreground triggered the other flashguns; an exposure time of one second was short enough to prevent excessive over-exposure of the window area.

The half-landing on a double-flight staircase provides an ideal point from which to photograph. The camera, with wide-angle lens, is set perfectly vertical to show maximum baluster detail without convergence of verticals (93).

A low viewpoint at the ground

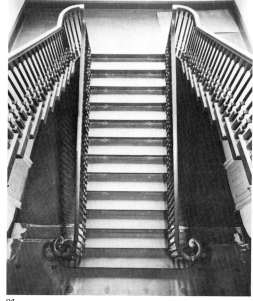

91

floor emphasizes essential features (94). Almost shadowless illumination is produced by a series of flash-lights directed at the stairs from various positions, including the landings. The window, facing a wall in shadow, and the low level of available light enabled a long exposure time during which the photographer, passing in front of the camera, could reach each flash location without being recorded on the film.

92

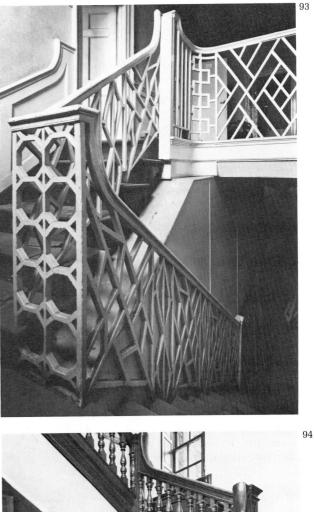

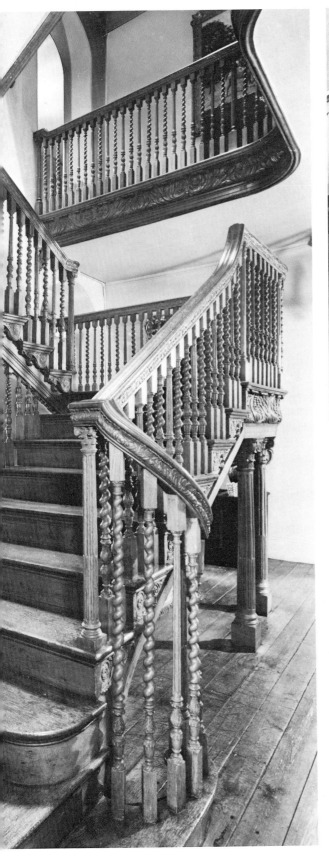

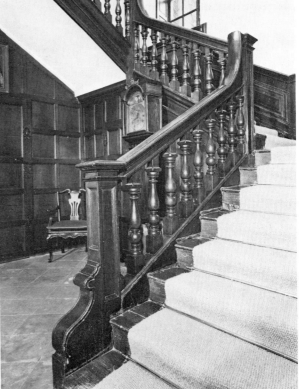

Natural lighting

A combination of sunlight through clear glass, gilded decoration and dark-stained woodwork (95): a complex problem that was solved without additional lighting. The exposure was made for the dark wood and the development, in a compensating or soft-working developer, is slightly reduced to retain detail in the highlights. A general rule for internal naturally-lit subjects is to give exposure for the dark or shadowy areas and process for the lightest area.

Details, such as this shuttered window, give an impression of the overall quality of a building. A combination of effectively-used lighting and clear detail make this photograph an adequate record (96).

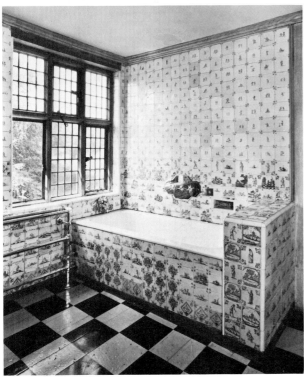

98

Flash-lighting

A solid fuel-burning stove has been placed in front of an earlier fireplace, which was itself inserted into the original fire opening, all using the same flue. This record shows development directly related to the domestic and economic needs of the occupiers from the time of erection of the house to the present day (97). Three flashbulbs were used, one on either side of the central beam, but avoiding reflection from the suspended mirrors, and one in the passageway.

Reflecting subjects lit at 45° to their plane surface will direct reflection away from the light source. This method produced maximum effect on a tiled bathroom when a fill-in flash was used from the camera position (98); light reflected from each wall illuminated the other wall.

Flashgun techniques

When a subject in shallow relief is alongside a light-toned wall, flash-lighting from position A in the open area will be reflected back from that adjacent wall, reducing the density of shadow available to show relief. To obtain maximum contrast in this situation, the lighting should be from a position B close to the adjacent wall (99).

Direct lighting reveals an incised design where this is of a different tone from that of the main surface (100).

99

Side-lighting creates contrast by producing shadow and thus provides more information about the surface texture (101).

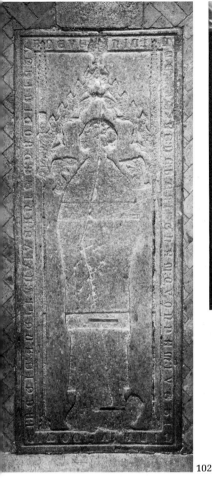

102

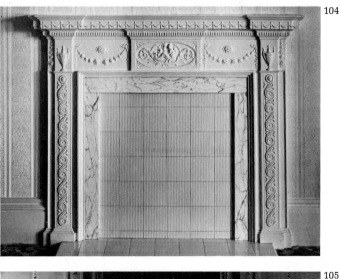

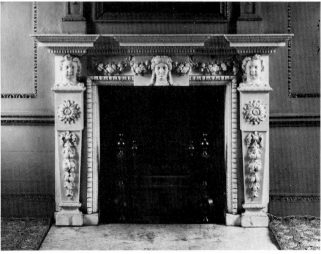

When a subject is immovable and the lighting cannot be placed for maximum effect, the unevenness of light which occurs can often be corrected by shading some of the light from the negative while the enlarged print is being made (102).

Where there is no alternative to placing lighting close to and at an oblique angle to a subject with a lengthy plane, a rapid fall-off in the intensity of the illumination occurs (103). Where possible the light should always be moved away from the subject and if necessary the exposure increased. Adding another light from the other side would even the illumination but reduce the contrast of shadow relief where the subject is raised.

Side-lighting with flash from a sufficient distance away to prevent uneven illumination, and increasing development time, gives enough contrast to show the applied raised decoration (104). A similar subject, lit only by daylight and given enough exposure to record detail in the shadowed areas, will require reduced development to keep contrast within a satisfactory range for printing (105).

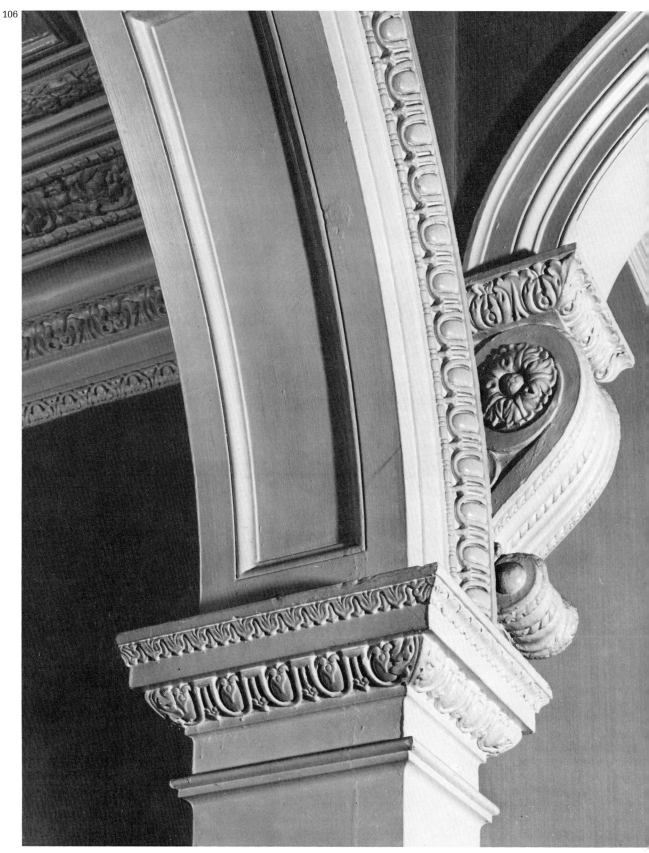

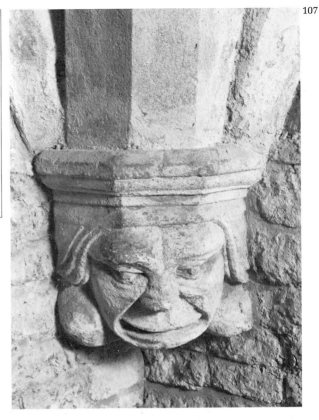

Direct flash
When a subject has more than one plane, direct lighting should be used to provide maximum information on the plane nearest to the camera (106).

Diffused flash
A soft lighting quality is produced when the light passes through a white translucent material before reaching the subject. A handkerchief, a piece of sheeting, or some types of flash brolly can be suitable diffusers (107).

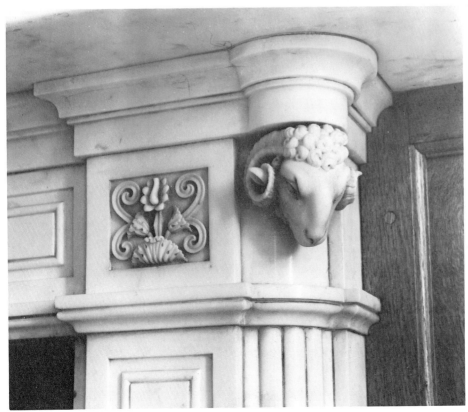

Bounce flash
Light indirectly reflected from any white surface on to the subject is even more diffuse. A white-painted wall, a white card, a white flash brolly, or even a sheet of newspaper are all effective for this purpose (108).

108

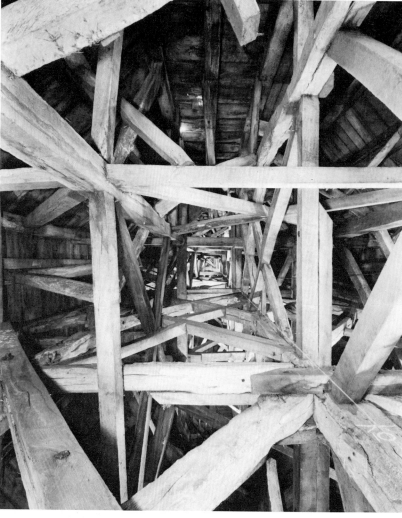

110

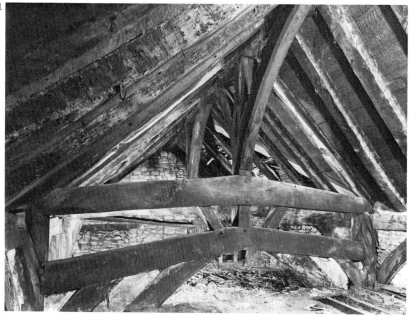

Difficult locations

The framework of the church spire, normally in total darkness, was lit at frequent intervals by flash-lighting from each stopping place as the photographer climbed to the top (109). The camera lay on its back in the centre of the floor with the shutter left open until the photographer returned. The exterior photograph of the church spire (110) gives little information about the tremendous amount of structural detail it encloses.

Total darkness allowed the shutter to be left open while a number of flashes from around the camera were directed towards this roof truss (111). The flashgun was fired several more times from behind the partition at lower left before the shutter was closed.

A cruck truss so brightly lit at its base by daylight that maximum illumination from the flashgun was required to light the apex during a very brief exposure (112).

This subject (113) could not be approached very closely so an exposure reading was made from a sunlit area outside the building, similar in lighting and tone to the sunlit timber beneath the unroofed opening. The aperture used corresponded with the synchronizing shutter speed for correct exposure; the flash-lighting, with its output suitably adjusted, was then used as a fill-in to reduce lighting contrast.

Although the advantages of using a good quality tripod in difficult locations cannot be over-emphasized, attaching a camera to the top of a telescopic pole with flashgun attached can be a solution for photographing inaccessible places (114).

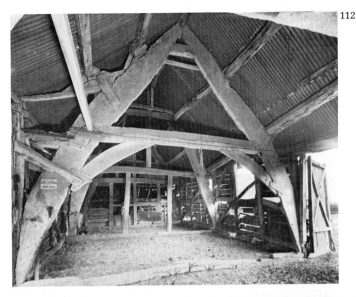

112

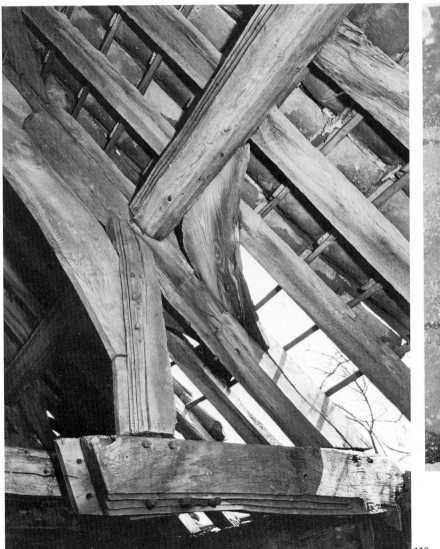

113

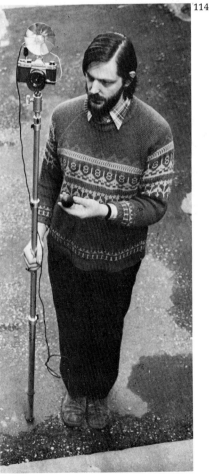

114

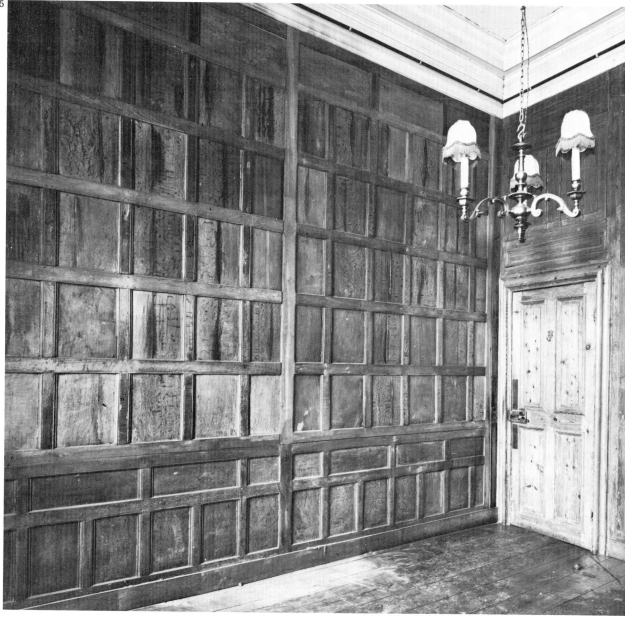

115

Panelled rooms

Dark-stained panelling requires a high level of illumination coupled with increased exposure.

Photographing diagonally into the corner of a panelled room prevents the illuminating-source at the camera position from being reflected as an intense light spot. Where there is a sufficiently high level of available daylight the meter reading is taken

from an intermediate tone, in this photograph the door, and increased by a factor of four. A flash can be used to give added sparkle to polished mouldings (115).

Very dark woodwork, highly polished and in a cramped situation for photography, always presents problems. The whole room is reflected in the glazed surfaces so that introduced lighting will always be seen and recorded by the camera (116). If the

opposite wall is light-toned, maximum light reflected from this will give the best effect. A large aperture will help to reduce sharply-defined reflection. Where the surrounding area is dark-toned, reflective surfaces should be carefully introduced. In this photograph a length of expanded poly-styrene wall-covering was unrolled across the floor to give depth to and lighten detail at the base of the panelling (117).

72

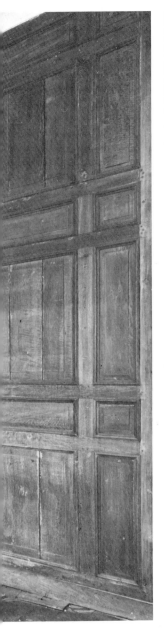

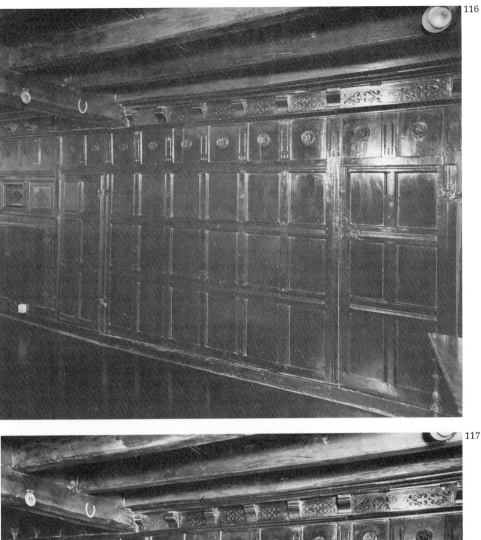

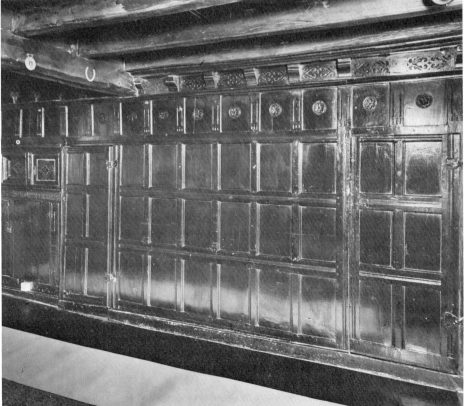

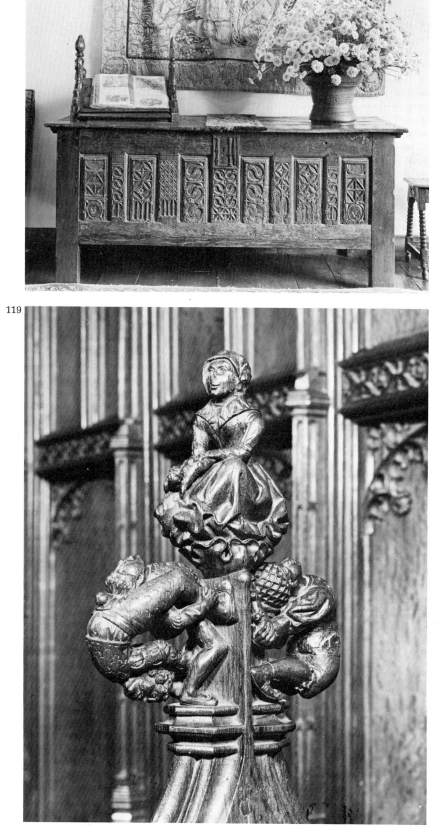

118

119

Woodcarving details

The lighting of carved-wood details is often easier to control than larger areas of dark panelling. Where the subject is illuminated by diffuse daylight (118), a satisfactory exposure may be made by taking a meter reading of the general area and, multiplying the exposure time by four, e.g. indicated exposure 1 second at f/8: actual exposure 4 seconds at f/8.

Free-standing subjects can be lit from several flashes, one directed at the background to give even illumination, one from behind the subject to give shadow relief and highlights, and one from the camera position to soften shadow contrast. A wide aperture is used to separate subject from background and the flashguns are held higher than the subject to produce a natural shadow effect (119).

Lighting details of a subject from in front of the camera, where the shadow is projected back towards the camera, accentuates carved relief (120). To avoid a flat effect the fill-in light from the camera position should be further from the subject than the shadow-producing back-light.

Carved bosses can be lit by several flashes to give soft, detail-revealing lighting, or by strong side-light to show design and depth of carving (121). Where the boss is on a high and dark roof, lighting should be chosen which will give maximum illumination, especially if the boss is unvarnished and so darkened with age that it reflects very little light.

When photographed straight-on, panels in relief can be lit by one lamp outside the reflective area and far enough away to give even illumination (122). This is similar to the technique for copying where the light is placed at 45° to the plane of the subject.

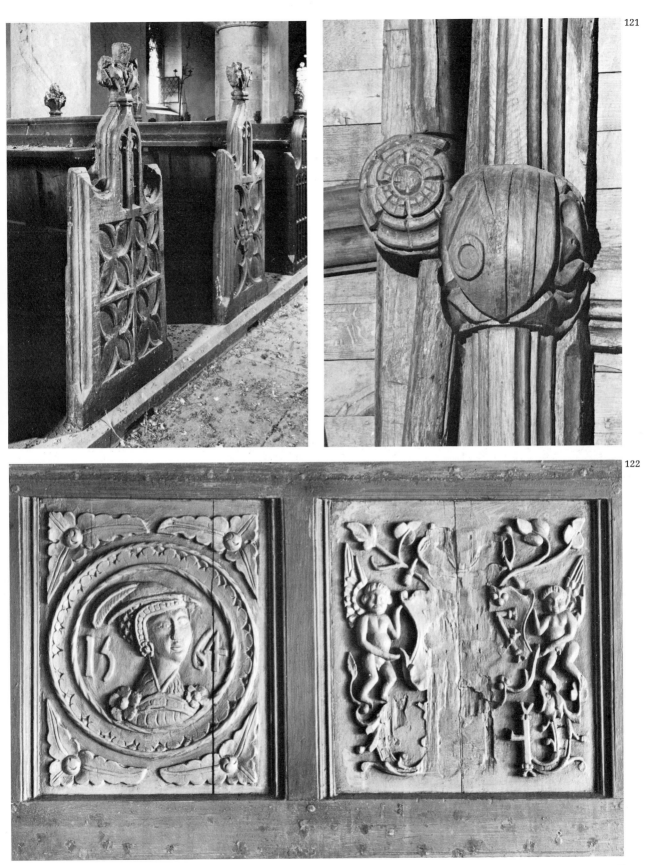

Metalwork

Daylight gives the most natural appearance to polished metalwork. A large aperture combined with a close viewpoint prevents reflected images from being too sharply-defined and also helps to separate the subject from its background (123). Where the metal surfaces reflect light unevenly, additional highlights can be introduced from white reflective surfaces: card, sheeting, expanded poly-styrene or any other easily available material will do (124).

A close viewpoint and large aperture were used on this ironwork to make it stand out against a confusing background. Heavy shadow on the black paint produced by side-lighting from sunlight was reduced by reflecting light on to the shadow side by using a sheet of newspaper (125).

A delicately-decorated baluster was lit by diffuse lighting to reveal its tracery. A greater level of illumination on the background shows the balusters in silhouette but without deep shadow (126).

The balusters are defined by the use of strong side-lighting to emphasize detailed casting; the light and dark sides of the uprights are at greater tonal extremes than the mid-tone of the background (127).

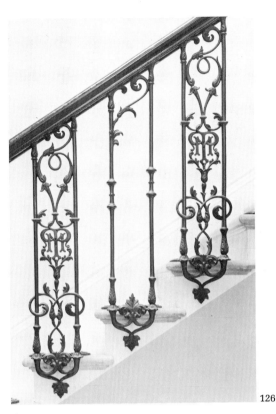

126

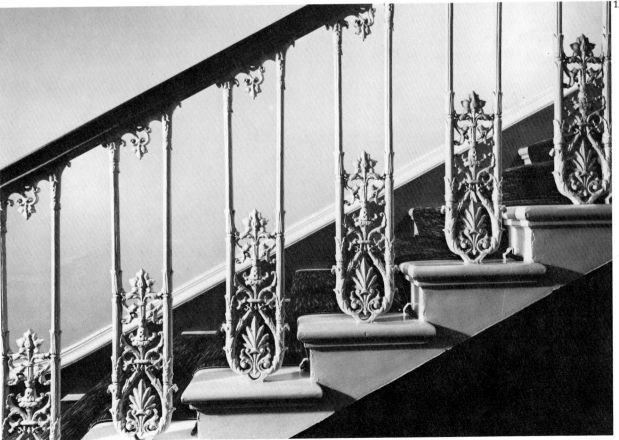

127

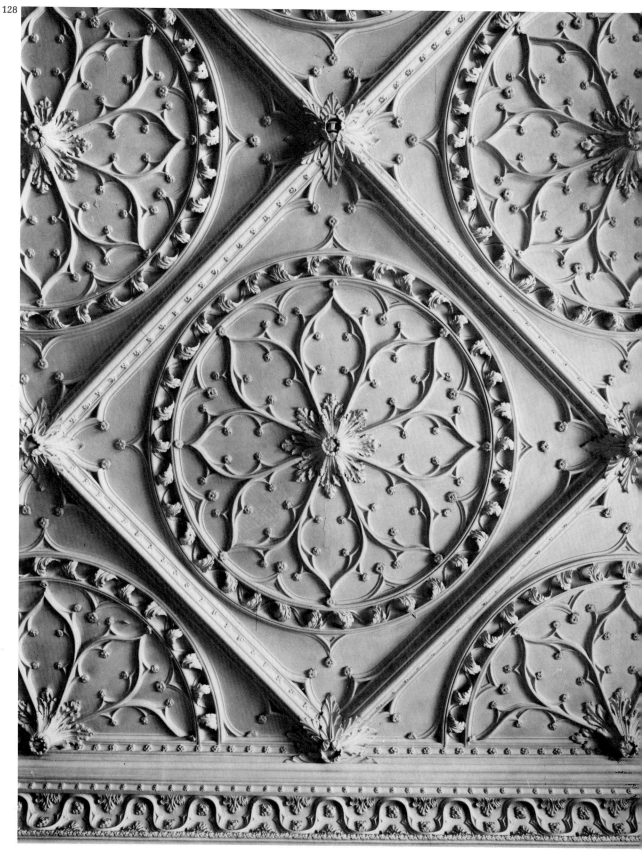

Plasterwork

Part of a ceiling illuminated by daylight from windows on one side of the room. The film, rated at its recommended speed, was exposed for the time indicated by an over-all meter reading of the area in order to retain natural subject contrast (128).

A ceiling motif for which the camera was placed on the floor directly beneath the central point; the camera was then carefully levelled to prevent distortion (129).

The use of reflected or very diffuse lighting is the only way to avoid shadow from a pendant light fitting (130).

To prevent excessive shadow contrast, this ceiling with gilded and painted decoration in relief was illuminated entirely by artificial light reflected off the adjacent walls (131).

129

130

131

132

Techniques for ceilings

A photographic recording can be a valuable aid when decorative architectural features are to be moved elsewhere. The ceiling was photographed in many sections in its original position by placing the camera on its back on the floor and moving it to new equidistant positions for further exposures (132). Particular care was taken in levelling the camera to ensure that the plane of the film was parallel to the ceiling. Once the initial

focus setting was made it was left unaltered for the complete sequence. The image size therefore remained constant and created no problems at the negative printing stage and subsequent montage. A number of tall obstructions limited the positioning of the flash-lighting and account for the slight variation in tone of the composite print. This could have been corrected during printing but was considered unnecessary for a working

photograph which was required only to assist in the correct reconstruction of the ceiling.

A natural viewpoint, with back-lighting emphasizing the relief, shows the reconstruction in its new position (133).

The opportunity was taken to photograph, from the scaffolding used to remove the ceiling, the cornice in its original position (134).

133

134

Ceiling details

Reflections from a painted ceiling can be avoided by pointing the camera away from that end of the room which is the source of both natural and artificial light (135). If the camera is positioned at the base of the composition, the final print should be turned upside down for viewing (136).

Where painting and white plasterwork are together the exposure should be given for the darker painting and the development time reduced slightly to avoid excessive contrast (137).

Illumination for a cornice in low relief should be placed near the ceiling (138).

Reflected daylight or diffuse illumination will show detail in all parts of white-painted high relief (139). Over-exposure should be avoided, but a slight increase in development time will increase contrast where required.

135

136

138

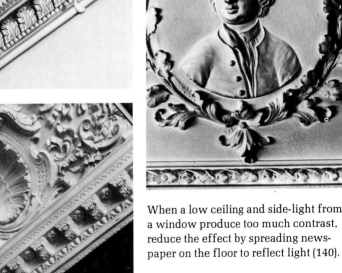

When a low ceiling and side-light from a window produce too much contrast, reduce the effect by spreading newspaper on the floor to reflect light (140).

139

Constructional details

The various forms of beam-stops can be lit in different ways but in most cases the camera position remains constant if the stop on one side only is to be shown. The stop should be in sharp focus and lit to show shadow or highlight on the front cut-edge across the angle of the beam (141).

Lighting from both sides prevents harsh background shadow and shows stops on connecting joists (142).

Where the chamfer is moulded, lighting placed above the level of the underside of the beam and near to the wall casts an effective shadow (143).

A viewpoint from the underside of the beam to show both stops is effective where the carved decoration extends beyond the stop. Both sides of the beam should be illuminated in the same way (144).

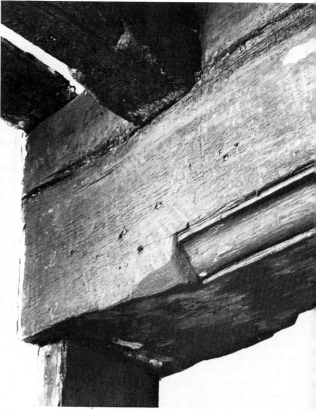

143

141

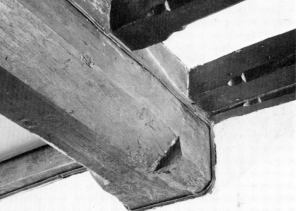

142

144

145

If a beam which rests on a corbel is lit from close to the wall on both sides, the supporting projections will retain their form (145).

In timberwork, photography can record only limited information about constructional joints (146), e.g. the position of pegs or wedges or the profile of the cuts.

Here a scarf joint (147) was related to another which had parted (148). Both joints were photographed to give as much information as is possible with a camera, supplementing a drawn record.

Although structural timber may have decorative embellishment (149), a correct choice of lens and appropriate lighting are important to help reveal its function. Peg holes, joint breaks, separate pieces of timber and stops should all be visible in the photograph.

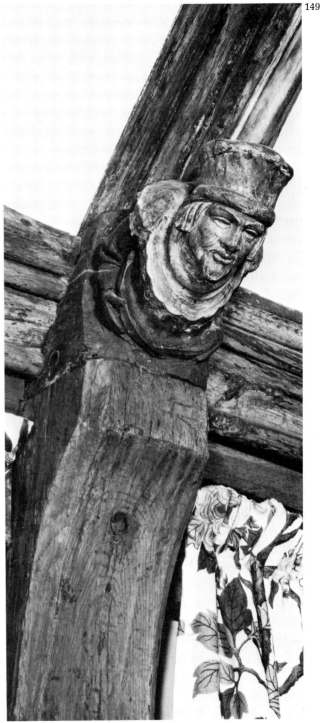

149

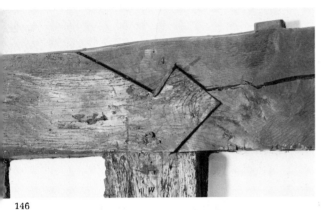

146

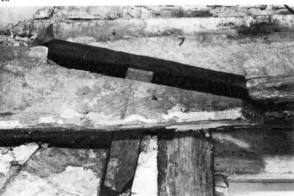

148

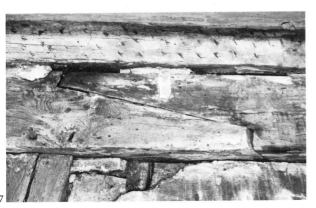

147

Dates

Dates must be recorded both with the camera and in the notebook; they may have to be searched for. Here an inscription on the beam was partly obscured by a later ceiling (150).

Side-lighting is the best illumination if inscriptions project from the surface, as on a cast-iron structural member (151) or an external lead rainwater head (153), or are incised (152). If artificial light, either flash or tungsten, can be introduced, the problem is easily solved. Where the date is high up on the exterior, wait for the sun to reach the correct angle for photography; if it is in permanent shadow or on the north elevation, contrast can be increased in the negative by an exposure slightly less than that indicated by the meter combined with an increase in development time.

150

151

15

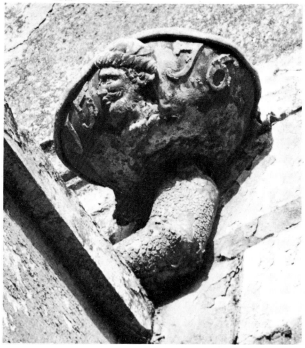

152

All-white subjects

Control over both lighting and contrast is desirable when coping with a most difficult photographic problem, namely the all-white subject.

This garderobe doorway was lit so that the shadow from the jamb exactly met the internal corner, thus giving an indication as to the dimension of the room itself; textural shadow variation from this lighting gave visual separation to the walls directly in front of the camera (154).

The font was lit by flash diffused through a piece of white translucent material at an angle to create a soft shadow at the base of the bowl. Double the amount of lighting (two flashes) was given to the background; exposure and development were kept to a minimum to avoid a negative of unprintable density (155).

155

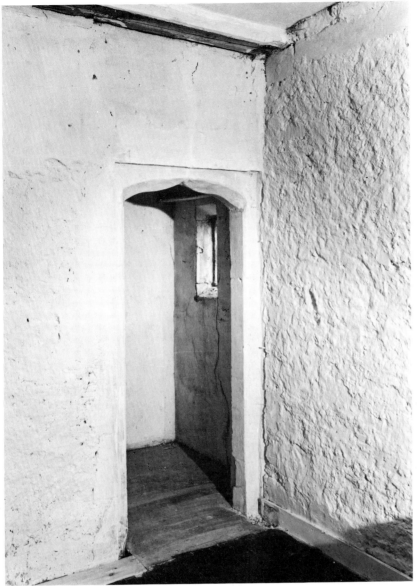

154

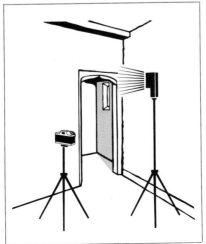

Explaining functions and revealing detail

To show how an architectural feature functioned, lighting should be arranged to illuminate its complexity at work rather than its simple aspect, e.g., a door open (156) rather than a door closed (157).

To produce a consistent comparative record between the two photographs, the lighting should not be moved. Three doors with empty space in front of them (158); the second photograph reveals the function (159). The static camera retains the scale in both photographs which provide an excellent example of thoughtful recording.

Here (160), the available daylight was bright enough for exposure without additional illumination but, with the door closed, both it and the door jamb matched the tone of the dark wall. Opening the door made use of the daylight in the adjoining room and also revealed a decorated top hidden when the door was closed.

Informed selection of a viewpoint, recorded in one photograph all the essential features of this donkey-mill (161). Care was taken in exposure and development to prevent the brightest area at the top of the wheel from losing detail.

Restrictive surroundings dictated this viewpoint and necessitated flash-lighting being carefully placed to show the shape and structure of the donkey-wheel to best advantage (162).

156

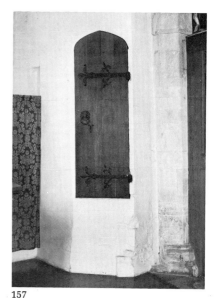

157

160

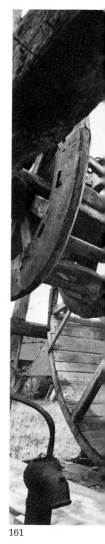

161

158

159

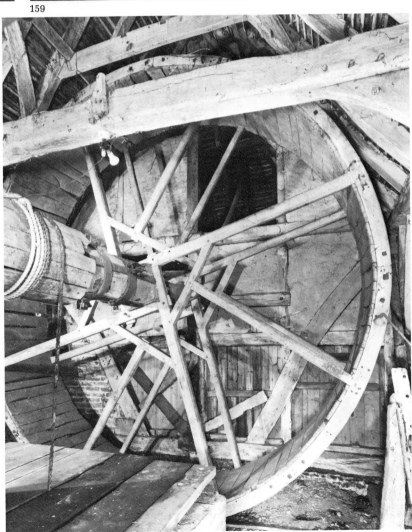

162

89

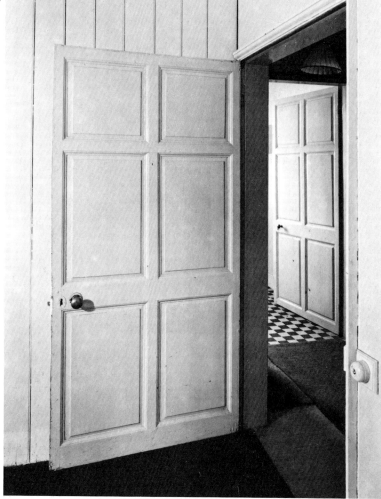

Doors

In photograph 163 the nearer door was lit by direct oblique flash-light and the further door by flash-light bounced into the corner of its room. One photograph gives maximum information and suggests that a standard door type was used throughout this house.

The best angle for lighting a closed door is usually 45° to the plane of its surface. Flash-light (164), or available light (165), serves equally well providing each is some distance away from the subject. To prevent the verticals converging, the camera should be brought level with the mid-point of the door, by the photographer either using a low tripod or dropping down on to one knee. A fireplace should be photographed from a similar position.

A dark recessed door (166), very close to a window which produced bright uneven light. To even out the illumination and increase detail in the shadow, a flash-light was used from the side opposite the window.

In this photograph (167) bright metal door furniture was lit by overhead flash to produce shadow, accentuate detail and prevent the specular reflection that would occur with direct lighting from the camera position.

164

165

166

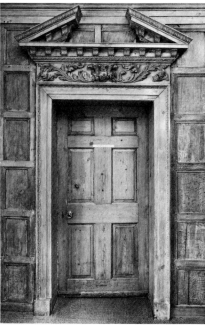

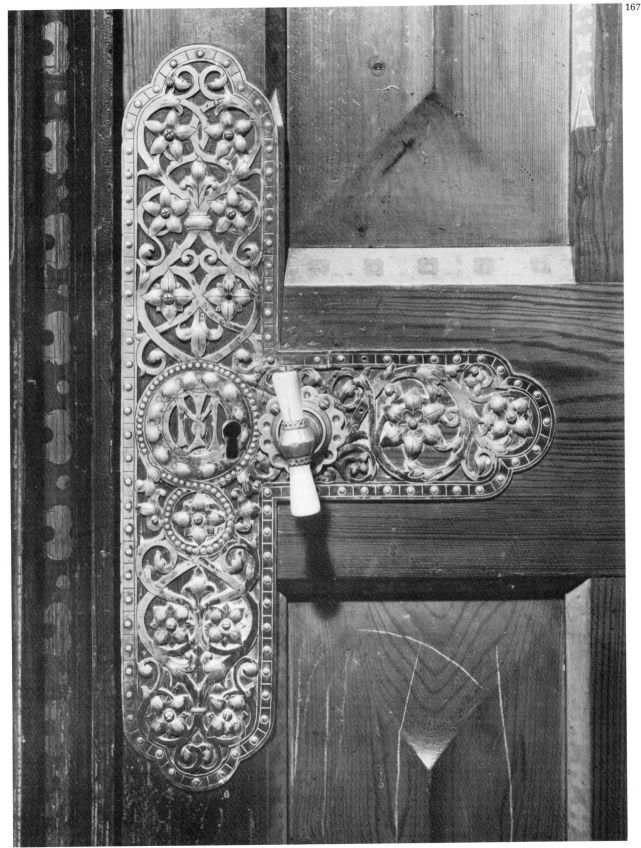

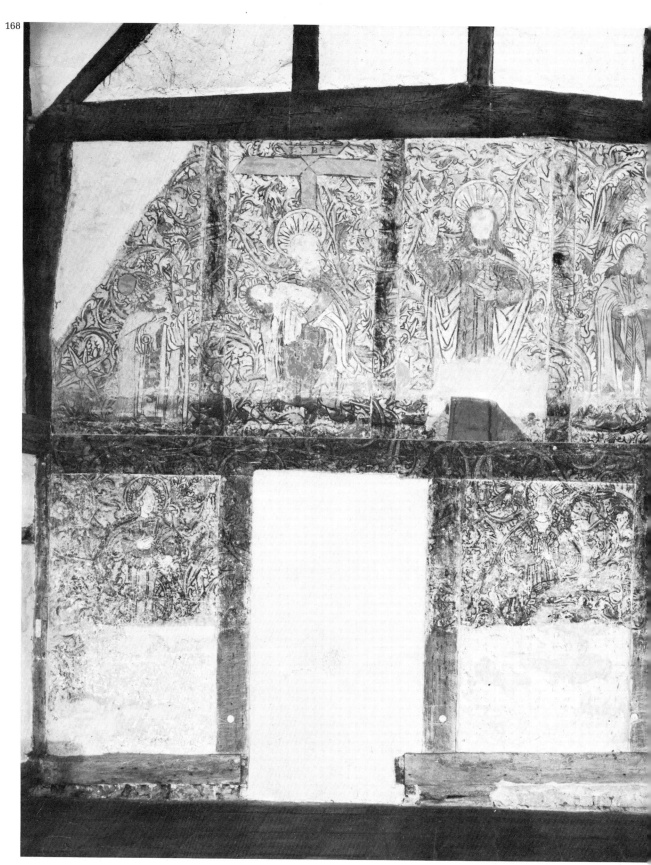

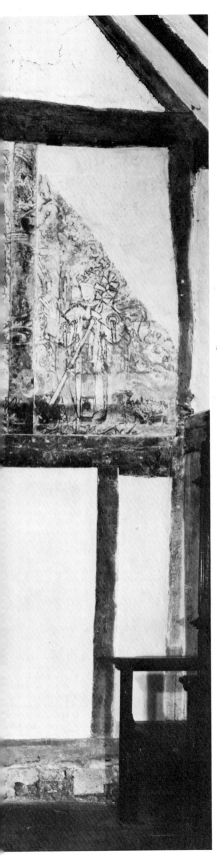

Wall-paintings

To produce this composite photo-graph (168) two photographs were taken. One was at first floor (169) and the other at ground floor level (170). The camera positions were vertically in line, enabling the two prints to be matched to show the whole wall as one. Provided the same lens, similar lighting and corresponding camera positions are chosen, this method can be used too for timber framing at different floor levels.

Wall-paintings need recording in colour as well as black-and-white; details of original technique and current deterioration in the painting should also be recorded. A varnished or glossy surface can produce a reflected glare if direct lighting from the camera position is used carelessly.

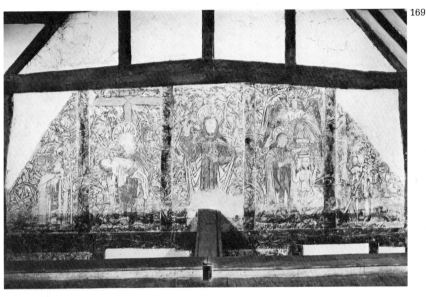

169

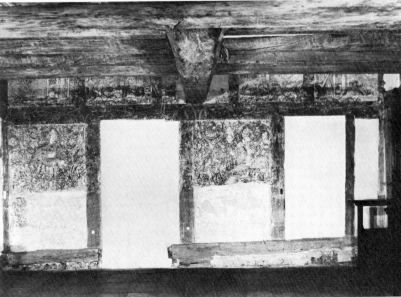

170

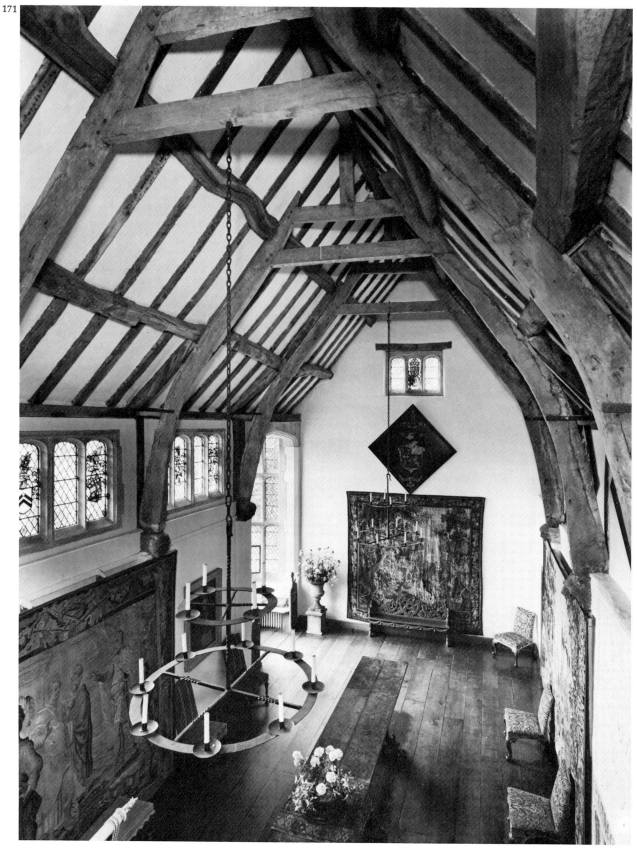

Examples of good interior photography

This photograph of a hall takes advantage of a high viewpoint to emphasize the roof construction (171). Daylight produced the exposure for the lower area; flash-light was directed towards the much darker timber trusses.

Exposure was based on the daylight in the lower foreground of this stair-hall (172); a meter reading taken from a white card held in that area had the exposure time multiplied by two. Tungsten illumination was used to raise the light level on the upper floor. Development was kept to a minimum to prevent excessive negative contrast.

A large room (173) for which a general exposure reading of the available light was taken and the exposure time multiplied by four. Additional flash-light from above the camera position added a sparkle to the woodwork.

An interior of dark-stained wood-work was given a long exposure based on the available light from unseen windows on the left (174). Flash-lighting was then aimed into the subject, three times from around the camera and three times from behind each column; each flash was aimed in a slightly different direction.

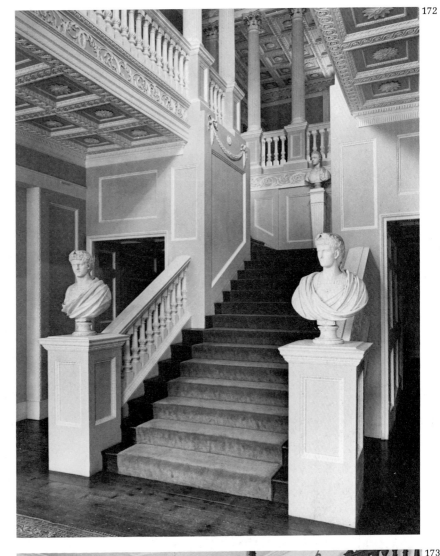

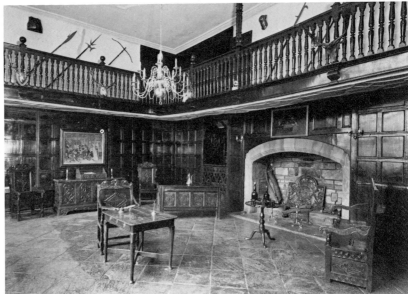

Large interiors

Large interiors can require a very high level of illumination in addition to the existing lighting (175). But they can also often be sufficiently represented by a small area over which the lighting is more easily controlled (176).

In this building a view towards the stage, using only some of the existing lighting together with flash-lighting, allowed a long exposure without the distracting auditorium lights producing over-exposed areas on the negative (177).

175

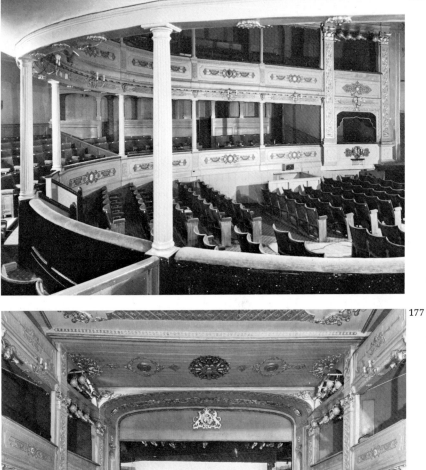

176

97

LARGE INTERIORS – continued

Only the available light was used for this church interior, with an exposure reading taken from the dark area of the choir stalls (178). Careful processing of the negative was the most important stage in producing this photograph, a surface-working developer being used to retain detail in the window and in the dark woodwork.

The exposure for this photograph of a barn (179) was based on the daylight area at bottom centre; the exposure time was multiplied by four. The roof was lit by flashbulbs fired from around the camera and behind the sacks.

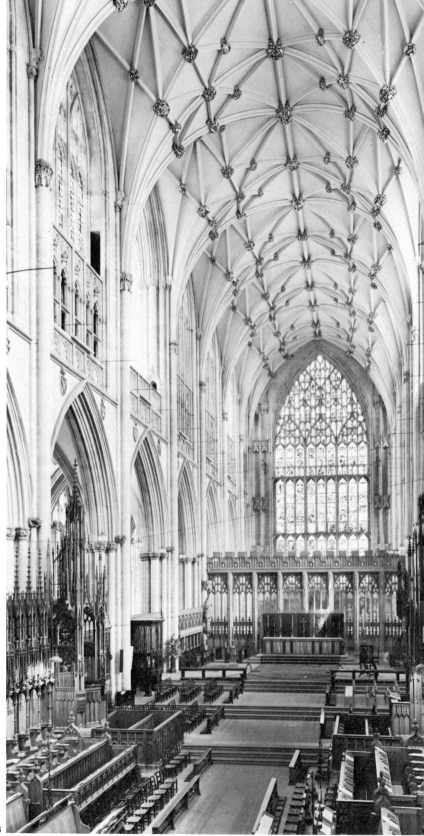

178

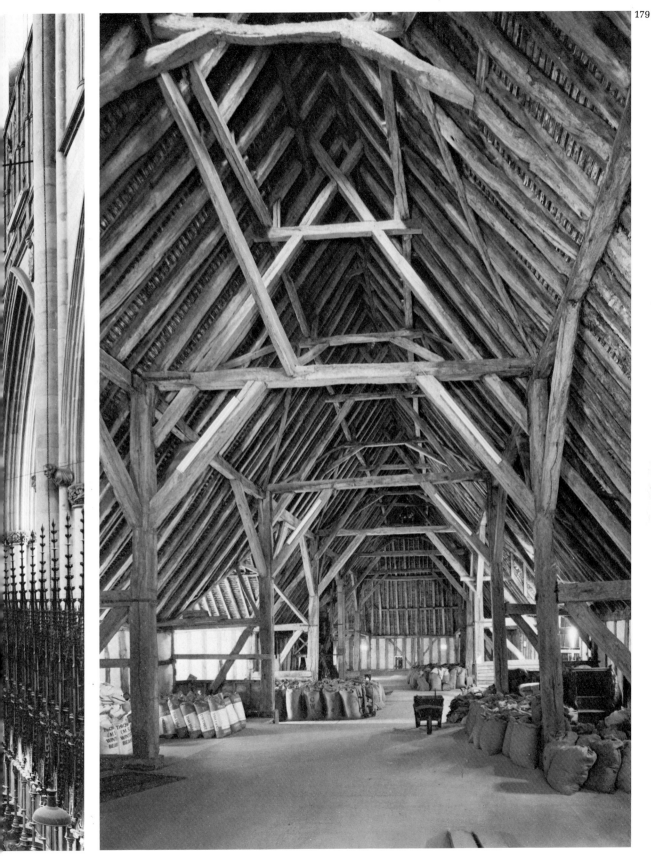

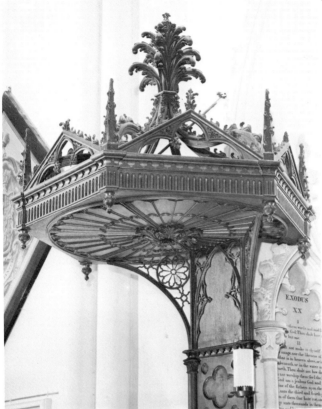

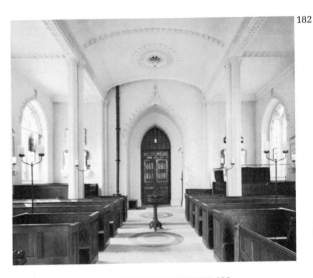

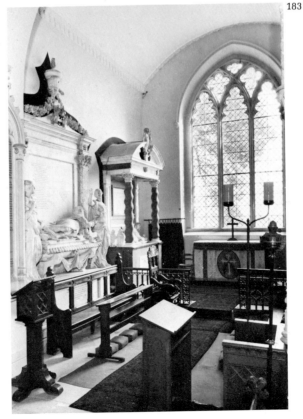

Church interiors

For this general view of a pulpit, flash was used as a fill-in light source, but the over-all exposure value was calculated from the window light and, although doubled, the exposure time used gave minimal loss of detail in the glazing bars (180).

The sounding-board had basically the same exposure time but, in addition to the flash from the camera position, a slave-unit flash was placed on the floor of the pulpit pointing directly upwards (181).

With church interiors the exposure should be so calculated as to prevent the windows giving heavy unprintable density on the negative. With light interiors and short exposures this can be controlled adequately; with very dark interiors, a longer exposure will create problems unless a large amount of artificial or flash-lighting can be introduced.

Many views will be needed to make an adequate record of a church, for instance of the nave (182), the chancel (183), and the transepts where they occur, etc.

Brasses

It may be difficult to see inscriptions and details on brasses from photographs (184, 185); if, however, the film negative is contact-printed on to line film, a paper print from the resulting film positive (transparency) will show a black line on white (186, 187). This is the way in which the eye is used to receiving graphic information; it is also probably the way, black on white, in which the original design was drawn.

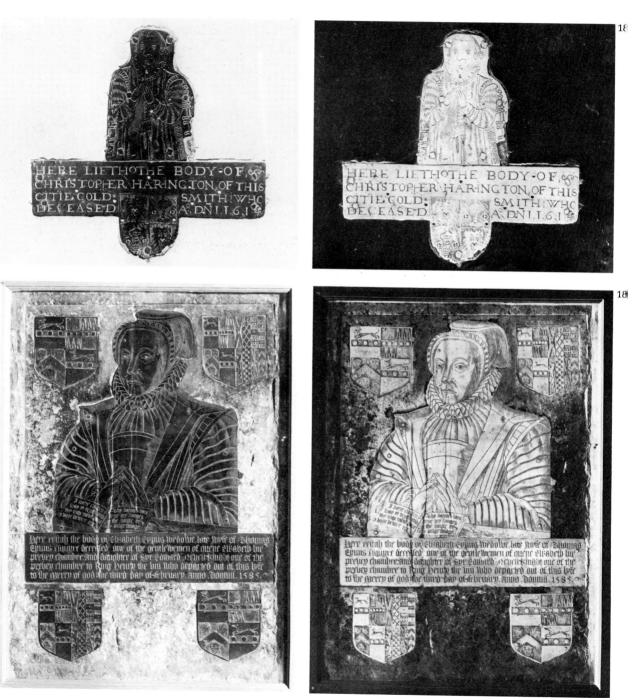

184

185

18

18

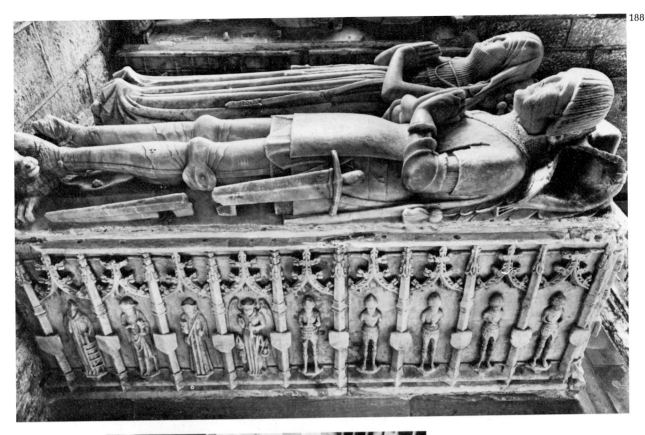

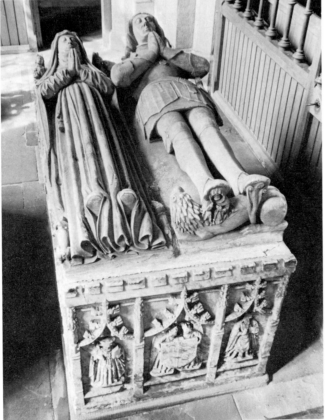

Effigies

The record of a tomb with reclining figures should consist of two views, from the side to show detail of clothing, equipment and decoration (188), and from above to show proportions, posture and relationship of the figures (189).

Available daylight was used for both these photographs, the exposure time being multiplied by four and the development time reduced by one third. In this way excessive contrast was controlled, making detail visible in both the shadows and the highlights.

Stained glass

Stained glass should be recorded both in black-and-white and in colour. Glass removed for repair can be photographed in sections or pieces on the light-box used for inspection by the glaziers (190). The light-box method enables parallel corrections to be made, and many individual photographs can by montage be assembled to provide a good representation of a whole window, possibly one that could never be photographed in its entirety in position (191). Where the glass panels vary in size, the largest should be photographed first; the camera, once set in position, should not be moved even if the glass panel does not match the film format (192).

Where the glass is in position in a window (193), the light will vary during the course of the day; direct axial sunlight should be avoided. Bright overcast daylight is ideal, particularly where the glass has an external protective mesh that produces shadow in sunlight. The exposure time usually needs to be multiplied, by eight times from a meter reading taken near glass of average tone and density, or ten times if red is the predominant colour. The same exposure corrections apply in all cases and the development time is reduced by half to show detail in the brightest and darkest glass.

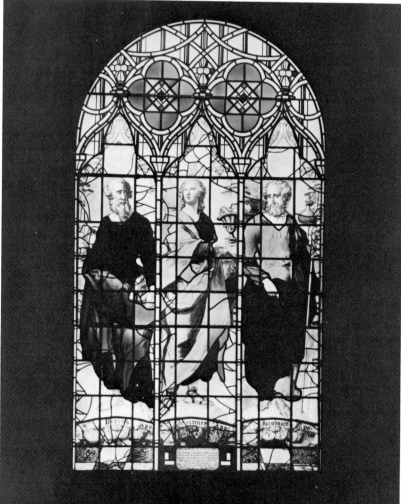

194

Inscriptions

The essence of a photographic record of an inscription is that the words should be, as far as possible, legible. This can usually be achieved by careful lighting and a well-chosen camera position. Often, however, especially in the slightly damp atmosphere of a church, condensation encourages the formation of a layer of dirt on the various fittings which can obscure the inscription (194). By gently wiping the surface of, for example, a stone, with a soft cloth and nothing else, the moisture may be removed. Here this has revealed the medium, a natural blackstone, and clarified the text (195).

Except in an emergency, however, touching any art object is to be avoided; advice regarding handling should always be sought from a trained conservator. If in doubt, do not touch.

General Index

Location Index Illustration numbers are shown in italic

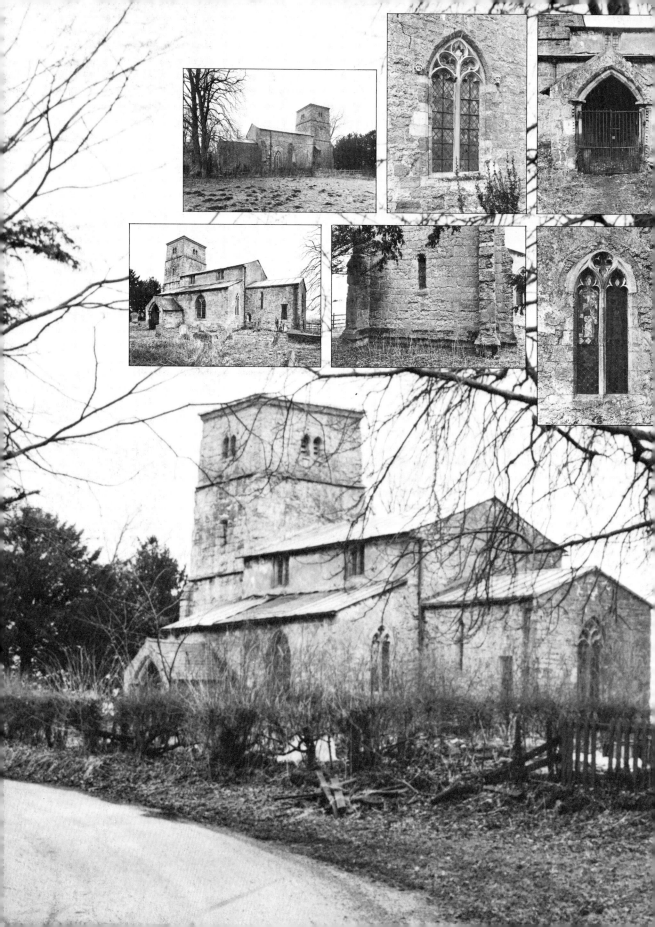